50 Texas Artists

CHRONICLE BOOKS • SAN FRANCISCO

50 Texas Artists

A CRITICAL SELECTION OF PAINTERS AND SCULPTORS WORKING IN TEXAS

BY ANNETTE CARLOZZI • WITH PORTRAITS OF THE ARTISTS BY GAY BLOCK

COMPILED BY LAUREL JONES

Printed in Japan.

Chronicle Books
One Hallidie Plaza
San Francisco, California 94102

Library of Congress Cataloging-in-Publication Data
Carlozzi, Annette.
 50 Texas artists.
 Includes index.
 1. Art, American—Texas. 2. Art, Modern—20th century—Texas. 3. Artists—Texas—Psychology. I. Block, Gay. II. Jones, Laurel. III. Title. IV. Title: Fifty Texas artists.
N6530.T4C37 1986 709′.764 86-14704
ISBN 0-87701-399-3
ISBN 0-87701-372-1 (pbk.)

Acknowledgments
The artists and collaborators in this book owe a tall Texas thank you to the following—Gene Binder, Joyce Brewster, Francine Carraro, Jim Edwards, Susan Frudenheim, Sue Graze, Dave Hickey, Fredericka Hunter, Bill LeBlond, Ed Marquand, Marti Mayo, Becky Duval Reese, Larry Smith, Murray Smither, Barru Whistler, and Thomas Zigal.

The following collectors, galleries, museums, artists, and photographers have graciously allowed the use of their work in this book:

Santa C. Barraza
Courtesy of the artist. Grant Dinsmore photo.

David Bates
Courtesy of Laila and Thurston Twigg-Smith, Honolulu, Hawaii.

John Biggers
Courtesy of the artist. Earlie Hudnall photo.

Ed Blackburn
Courtesy of Dr. and Mrs. William F. Runyon. David Wharton photo.

Derek Boshier
Private collection, Houston. Rick Gardner photo.

Bob Camblin
Courtesy of the artist. Ray Balinskas photo.

Mel Casas
Courtesy of the artist. Tom Wilson photo.

Martin Delabano
Courtesy of Cary Esolen, New Orleans. Owen Murphy photo.

James Drake
Private collection, Houston.

Vernon Fisher
Courtesy of Butler Gallery and Barbara Gladstone Gallery. Julie Bozzi photo.

Roy Fridge
Courtesy of Moody Gallery. Marilyn Marshall Jones photo.

Harry Geffert
Courtesy of the artist.

Joseph Glasco
Courtesy of the Museum of Fine Arts, Houston. Paul Hester photo.

Linnea Glatt
Courtesy of Richland College, Dallas.

Joe Guy
Courtesy of the artist. Lee Clockman photo.

John A. Hernandez
Private collection. Julie Bozzi photo.

Dorothy Hood
Courtesy of Meredith Long & Co. Janet Woodard photo.

Luis Jiménez
Courtesy of the City of Houston—NEA Art in Public Places Commission. Gay Block photo.

Thana Laubakaikul
Courtesy of the artist.

Robert Levers
Courtesy of the artist. George Holmes photo.

Bert Long
Courtesy of Stuart and Donna Lewis. Rob Ziebell photo.

Jim Love
Courtesy of Janie C. Lee Gallery. Jim Sims photo.

William Jackson Maxwell
Sphere in foreground courtesy of James and Colleen Drake, El Paso. Patricia Simonite photo.

David McManaway
Courtesy of Mr. and Mrs. David Gibson, Dallas.

Melissa Miller
Courtesy of the Museum of Fine Arts, Houston.

Jack Mims
Courtesy of the artist and Moody Gallery. Bob Shaw photo.

Michael Mogavero
James Dee photo.

Nic Nicosia
Courtesy of the artist.

Madeline O'Connor
Courtesy of Moody Gallery. Hickey-Robertson photo.

Nancy O'Connor
Courtesy of Moody Gallery. Paul Bardagjy photo.

Jorge Pardo
Private collection. Bill Records photo.

Claudia Reese
Private collection. Carson Zellinger photo.

Peter Saul
Courtesy of Allan Frumkin Gallery. eeva-enkeri photo.

Richard Shaffer
Courtesy of the artist and L.A. Louver Gallery. Thomas P. Vinetz photo.

Lee N. Smith III
Courtesy of the artist and D.W. Gallery. James Flannery photo.

Gael Stack
Courtesy of Janie C. Lee Gallery. Jim Hicks photo.

Earl V. Staley
Courtesy of the artist and Texas Gallery.

Susan Stinsmuehlen
Courtesy of Kirk and Elizabeth Day Collection, Oregon. Lone Star Silver and Associates photo.

James Surls
Courtesy of the artist and Butler Gallery. Frank Martin photo.

Richard Thompson
Courtesy of Harris Gallery.

Patricia Tillman
Courtesy of Fort Worth Gallery.

Francis Xavier Tolbert[2]
Courtesy of the artist. Bic Green photo.

John Tweddle
Courtesy of the Metropolitan Museum of Art, New York.

Bob Wade
Courtesy of the artist. Clinton Bell photo.

Susan Whyne
Courtesy of the artist. Bill Kennedy photo.

Danny Williams
Courtesy of Butler Gallery and Barry Whistler Gallery. Julie Bozzi photo.

Bill Wiman
Courtesy of Adams-Middleton Gallery. Jim Dougherty photo.

Dee Wolff
Bill Poag photo.

Dick Wray
Courtesy of Moody Gallery.

Robert Yarber
Courtesy of the Frederick R. Weisman Foundation of Art. Bill Kennedy photo.

Contents

Introduction

by Annette DiMeo Carlozzi

There's no denying that much of the visual art made in a particular region reflects that region's character—its blend of historical traditions, social values, and physical landscape. When New York–based art critic Roberta Smith made a trip through Texas in 1976 for *Art In America* magazine, she wrote with great enthusiasm about the robust spirit she encountered here. "You can believe," she said, "that it's a place rich enough in weirdness and fantasy to produce heavy art."

The old myths of Texas bring to mind a vast frontier, dotted with ranches and oil wells, and a sparse population of good ol' boys content to champion their land, their football, and their barbecued beef. A new stereotype (largely created, like the old one, by the media and entertainment industries as part of America's continual reinvention of its roots) has provided us with new images: the mad-for-profit oil magnate, boots up on desk in his lavishly designed glass-and-steel corporate tower, and the urban cowboy, newly arrived and fueled to violence by his confusions about life in the big city. While these characterizations do have some basis in fact, life in Texas today is, of course, much more complex and richly textured than the movies and television would have us believe.

The urbanization of the state since World War II has been the catalyst for swift changes that have profoundly affected and complicated the lives of every person living here. In the transition from a rural to an urban society, many have gotten rich on oil deals, land speculation, industrial-service contracts, and the like, but more than a few have been troubled and saddened by their communities' concomitant loss of tradition and stability, and by the fading of a lifestyle rooted in the values of the frontier. The astounding variety of untouched landscapes that spreads across the 267,000 square miles of Texas has diminished as well. Coastal swamp, piney woods, wildflower-bedecked hill country, and windswept plain have given way to suburban tracts constructed to service the new, populous Sun Belt cities and their partnerships with corporate headquarters and large research facilities. To some extent, small-town life has disappeared all across America, but in Texas the psychological and spiritual distance traveled has been more rapid and more disturbing: the heritage of old-fashioned neighborliness, thrift, strong family bonds, and deeply held conservative religious beliefs has provided poor preparation for the fast-paced, profit-based life in Texas's metropolitan areas. The culture of the state is being redefined, and more and more of its peculiarities—the weirdness and fantasy that Roberta Smith noted so perceptively in 1976—are disappearing. Though still a land of eccentricity, colorful hyperbole, and outrageous characters, Texas is nonetheless becoming more homogeneous. Its relentless commitment to modernization has smoothed off many of its most genuine and enjoyable rough edges.

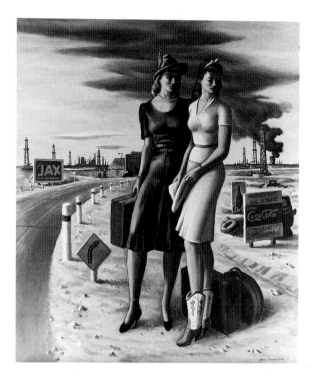

Enter the artists, whose role it is to examine the old values, critique the new, and assess the impact of change on our lives. What could be more vital than art made in this environment, in volatile, constantly shifting, never-predictable Texas? In the 1970s, critics like Roberta Smith found a fresh, direct appeal in Texas art, an uncensored humor and personal immediacy missing in the mainstream art centers, where artists were struggling to broaden the formalist dictates of the previous decade, to expand the artistic definitions that emphasized style, form, and material over content and meaning. While artists in New York were looking for conceptual links between the notion of fine art and the experience of popular culture—appropriating historical imagery in an attempt to lend human-istic values to their formalist abstractions—artists in Texas were making bold, confrontational statements about the rituals of contemporary life in their state. Refuting the myths about Texas perpetuated by mainstream culture, they drew upon the traditions of Southern narrative and mysticism and rural black and Mexican folk art for style and imagery. Humanism had always been inherent in the content of Texas art. By making reference to the heritage and mythology of their region, Texas artists strove to illuminate the clash of the new technological era with the values and experiences of the traditional Texas lifestyle. Yet, even as they unabashedly alluded to the region's geography, history, and cultural conventions, these artists

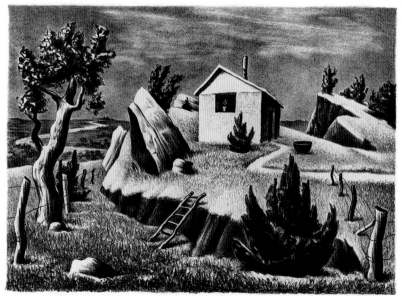

Above: Jerry Bywater, *Oil Field Girls*, oil on board, 1940, 29 ⅝ ″ by 24 ½ ″, Archer M. Huntington Art Gallery, The University of Texas at Austin, Michener Collection Acquisition Fund, 1984. *Below*: William Lester, *The Squatter's Hut* , lithograph, 1941, 9¹⁵⁄₁₆″ by 13 ⅞ ″, Dallas Museum of Art, Foundation for the Arts Collection, gift of Mrs. Afred L. Bromberg.

extended their vision beyond state boundaries and tried to transform a mere regional aesthetic into a more universal expression of twentieth-century American life.

The visual arts of Texas were chiefly concerned with historical documentation until the 1930s, when a remarkable group of artists working in Dallas made it their mission to champion the artistic interpretation of life in the state. Jerry Bywaters, Otis Dozier, Alexandre Hogue, William Lester, and Everett Spruce were among the spokesmen for a seemingly tireless band of painters, writers, architects, teachers, and patrons of the arts who met regularly and provided leadership and direction to the burgeoning Dallas arts community. In 1932 they formally organized as the Dallas Artists League, whose aim was to foster community pride in Texas art. The League's activities were various: organizing street carnivals and art exhibitions that featured local artists, stimulating critical dialogue through writings in such regional magazines as *Southwest Review* and *Contemporary Arts of the South and Southwest,* sponsoring public lectures with such visiting artists and critics as Gertrude Stein, and helping to found the Dallas Museum of Fine Arts in 1933.

Inspired by the example of the previous generation—the turn-of-the-century artist-educators Frank Reaugh, Robert Jenkins Onderdonk, and Onderdonk's son Julian, all of whom painted romanticized views of the Texas landscape rather than the European-style salon paintings that were fashionable at that time—the Dallas Artists League believed that Texas artists had something unique to say about life in the United States. The League maintained that art is a reflection of daily life, that it should be meaningful to its audience, and that it should acknowledge and celebrate indigenous cultures, like the Hispanic, American Indian, and plains and Southern agrarian cultures that forged an awkward meeting ground on the Texas frontier. League artists were conversant with the principles of their ideological artistic contemporaries—Diego Rivera and the Mexican mural movement, Thomas Hart Benton and the "American Scene" painters of the twenties and thirties—and were influenced by the writings of American philosophers John Dewey and George Santayana. Dubbing its creed the "New Regionalism," the League challenged the Texas audience to respond to art that addressed the social concerns of the times. Bywaters, Dozier, Hogue, and the others are recognized today for expressive paintings and prints that document, as clearly as do Russell Lee's photographs of the era, the despair of the Great Depression and its desolate effect on the land and the people in the agricultural communities of Texas and the Southwest.

Despite devastating economic and social conditions, the 1930s was a period of unprecedented cultural growth and support for artists in the cities of Texas. Commercial art galleries

like the Joseph Santor Gallery in Dallas, as well as artist-run cooperatives like the Artists' Gallery in San Antonio, directed much-needed critical attention to the local artists whose works they featured. Countless group exhibitions of Texas artists were organized by the statewide network of art leagues and art associations and were displayed at municipal art museums like the Houston Museum of Fine Arts, founded in 1924, and the Dallas Museum. The first several directors of the Dallas Museum were such ardent supporters of the new art in the state that they pledged four institutional priorities: support for local artists, support for art education, increased public involvement in the arts, and the encouragement of private patronage. (It is interesting to note that artist Jerry Bywaters became director of the Dallas Museum in 1943 and guided that institution until his retirement in 1964.) Advanced course offerings in art were developed or expanded at the University of Texas in Austin, Southern Methodist University in Dallas, and other colleges and universities throughout the state, as well as at private art schools like the Dallas Art Institute and public art schools like those affiliated with the Houston Museum and the Witte Museum in San Antonio. The federally funded Public Works of Art Project and its successor, the Works Progress Administration's Federal Art Project, provided many Texas artists with commissions in mural and easel painting, sculpture, and commercial design and broadened the audience for art in the state. But the most significant booster of Texas art was surely the Texas Centennial Exposition of 1936, a grand celebration that brought national attention to Dallas as an important regional center for art and to Texas artists as messengers of a new artistic spirit.

If the years preceding World War II marked the birth of a regional artistic philosophy and the establishment of arts institutions that supported the efforts of local artists, the new confidence and prosperity of the postwar years brought a greater sophistication to the Texas cultural scene and a welcome economic stability to those artists who established teaching careers here. In the late forties and fifties the work of Texas artists began to exhibit a wide range of interests—preservation of the rapidly vanishing Texas landscape, a personal mysticism inspired by travel to nearby Mexico and Latin America, and assimilation of the tenets of European abstraction that had revolutionized the most advanced art in New York several years before. Public exposure to important works of modern art was increasing. Prominent women of society, like Marion Koogler McNay of San Antonio and Anne Burnett Tandy of Fort Worth, began to build notable collections of European modernist painting, which would form the foundation for significant private museums in the late fifties. In 1955 the foremost patrons of modern art in the state, John and Dominique de Menil, recruited Jermayne McAgy from the Palace of the Legion of

Honor in San Francisco to direct a new contemporary arts institution to be founded by Houston artists and arts patrons. At the helm of the Contemporary Arts Museum for four years, McAgy established an impressive record of provocative exhibitions of European modernists and primitive art; she delighted the entire Houston arts community with her dramatic installation designs and suggestions for striking new ways of looking at modern art. In a serendipitous move for the state, McAgy's husband Douglas became director of the newly formed Dallas Museum of Contemporary Art, and together the McAgys helped to inaugurate a new intellectual climate for modern art—both European and American—in Texas. Their efforts, along with those of such other museum and gallery professionals as James Johnson Sweeney, who left New York's Guggenheim Museum in 1961 to direct the Museum of Fine Arts in Houston, paved the way for the beginning of a healthy gallery scene in Texas. It now seemed possible that Texas artists could someday make a living from the sale of their art without leaving the state.

The exuberant art scene that Roberta Smith discovered upon her arrival here in 1976 had been coaxed and nurtured and constantly reassured by a loosely organized statewide community of artists, critics, exhibiting institutions, and commercial galleries that had shared a commitment to contemporary Texas art for over a decade. When no one was ready to buy and few were willing to look, Texas art dealers Dave Hickey, Fredericka Hunter, Janie C. Lee, and Murray Smither promoted exhibitions of new work by Texas artists. They introduced secluded artists to wary corporate collectors and to the handful of well-to-do patrons of contemporary art in the state; they persuaded newspaper editors that Texas artists deserved to have their work reviewed and discussed in the metropolitan dailies; and when their small successes attracted dealers from New York who opened satellite galleries in the nascent Texas marketplace, they convinced themselves that outside competition, and the greater diversity of contemporary art it provided, would only increase their audience. (In most cases, the New Yorkers folded first.) At the same time, over a dozen small museums and art centers opened throughout Texas—without collections, workable budgets, professionally trained staffs, or suitable exhibition spaces, but with the firm conviction that Texas art was important to the state. Led by such astute museum directors and curators as Henry Hopkins, Robert Murdock, and Martha Utterback, these new institutions organized lively exhibitions and occasionally even purchased works of art for their fledgling collections.

But if proceeds from the sale of Texas art have usually fallen short of guaranteeing the artists, or even the dealers, a living wage, there has been no shortage of capital spent to memorialize newly made fortunes or to stake claims to cultural sophistication. As the population of the state has grown with the

fantastic success of the corporate community, city governments and private donors have realized that "great cities need great art museums" (Dallas's campaign slogan for a new city art museum). Design commissions for new arts facilities have been awarded to internationally renowned architects Louis Kahn (Fort Worth), Philip Johnson (Corpus Christi), Gunner Birkerts (Houston), Edward Durell Stone (Amarillo), and most recently Edward Larrabee Barnes (Dallas), Renzo Piano (Houston), and Robert Venturi (Austin). Private efforts to create public spaces for art have had results as varied as the de Menils' Rothko Chapel in Houston, Stanley Marsh's Cadillac Ranch in Amarillo, and Donald Judd's sculpture installations at an abandoned fort in far West Texas.

For artists living in Texas today, national attention has continued unabated since a surge of critics and curators, including Roberta Smith, first traveled through the state on a wave of Bicentennial boosterism. The art world has changed considerably in the past ten years. New York's preeminence as the center of the international art market has weakened, and critics and historians have focused anew on contemporary art made in Europe and in an ever-widening network of regional art centers throughout the United States. Texas artists now find themselves in the happy position of appearing in prominent mainstream exhibitions of "new talent" at New York's Whitney and Guggenheim museums, the Smithsonian's

Hirshhorn Museum in Washington, D.C., and the prestigious *Venice Biennale* in Italy. According to the director of the Visual Artists Fellowship program at the National Endowment for the Arts, the work of Texas artists is so highly respected that they receive a higher percentage of fellowship awards, in relation to the number of applicants, than artists of any other state.

Texas museums have continued to feature the art of their native sons and daughters, and are now publishing impressive, often scholarly catalogues to accompany such exhibitions as *What's Up in Texas?* (Witte Museum, San Antonio, 1978); *Fire!* (Contemporary Arts Museum, Houston, 1979); *Made in Texas* (University of Texas Art Museum, Austin, 1979); *Response* (Tyler Museum of Art, 1980); *Images of Texas* (Archer M. Huntington Art Gallery, Austin, 1983); *Lone Star Regionalism* (Dallas Museum of Art, 1985); *Fresh Paint* (Museum of Fine Arts, Houston, 1985); and *Currents* (San Antonio Art Institute, 1985). Ongoing exhibition series featuring works by Texas artists are sponsored by numerous museums in the state, including Laguna Gloria Art Museum, Austin; the Amarillo Art Center; The Art Center, Waco; and the Art Museum of South Texas, Corpus Christi. And the artists themselves, rightfully wanting to exert their own power and judgment in the decision-making process, have created organizations to provide resources and exhibitions for emerging artists, those who have not yet developed extensive records of museum and gallery

shows. A number of these artist-run alternative spaces have blossomed in Texas in the past several years, as groups like those affiliated with Houston's Diverse Works and Lawndale Annex, San Antonio's Guadalupe Cultural Arts Center, Austin's Designer Space, and Dallas's 500 Exposition have joined the ranks of longer-tenured statewide service organizations such as the Texas Fine Arts Association.

Though the development of cultural supports for contemporary art in Texas may seem comparatively recent and meager when measured against the impressive accomplishments of New York, a survey of other art centers in the United States— like that provided by this new series of books on the nation's contemporary painters and sculptors—reveals regional cultural histories that are roughly parallel, and isolated communities of artists who have faced similar challenges. *50 West Coast Artists, 50 Northwest Artists,* and now *50 Texas Artists* were conceived to provide a nationwide audience with critical introductions to significant artists of these areas and to the cultural environments that have nurtured their talents.

The fifty Texas artists featured in this volume represent almost every stage of creative accomplishment that characterizes an artistic career. There are promising younger artists who have been making art for about ten years and whose talent is just beginning to mature and be recognized; mid-career artists with considerable records of production and exhi-

bition who have completed major bodies of work and achieved some degree of success; and distinguished senior artists, acknowledged masters of their art, whose skills as teachers and mentors are equalled by the vigor and expertise apparent in their newest work. No two of these artists produce art that is essentially similar—unlike their predecessors in the thirties, they are united by neither style, philosophy, nor subject matter. But they do share the experience of making art in Texas, with all the limitations and advantages that this cultural environment affords, and they are surely affected by the choice to remain here. In looking over the works selected for reproduction, I see at least three concerns that I believe to be shared by a number of Texas artists, and I encourage you to consider them as you read the artists' statements and study their work.

Art that conveys a spiritual search. Confronted with our vastly commercialized American lifestyle and the particular emphasis in Texas on "progress" and profit as measures of success, many Texas artists strive to make art that communicates spiritual struggle and revelation. Artists James Surls, Roy Fridge, Dee Wolff, Jorge Pardo, and Martin Delabano, among others, look to readily accessible Southern/Southwestern and Latin traditions of folk art and devotional religious art in their efforts to convey perceptions of wonder and despair. Their work, encyclopedic in its use of recurring personal symbols,

romantically explores autobiographical detail and images of the transfigured self. Casting themselves as artistic visionaries, they present their art as a source for healing and a means to self-knowledge.

Art that evaluates the myths of American life. Living in Texas, one becomes adept at an early age at spotting the exaggerations and stereotypes that form the nation's image of Western America. (If not, one can look to the controversial new work of photographer Richard Avedon for a particularly grotesque interpretation of the region's mystique.) It is therefore natural for Texas artists to use art as a vehicle to satirize our collective cultural pretentions. Artists like Luis Jiménez, Robert Levers, Bob Wade, Ed Blackburn, and Robert Yarber parody traditional cultural icons, mock the glamour of modern romance, and magnify the melodramatic scenarios we create to invigorate daily life. Drawing their imagery from clichés of popular culture, they make art that is reactive, rooted to the moment, an expression of pseudo-heroism and contemporary bathos.

Art that responds to other art. To some extent, all trained artists participate in a dialogue with the history of art. The lessons of the past are always synthesized in modern work, the principles of an art-historical movement couched in contemporary terms and made personal and immediate. In Texas, the most influential twentieth-century tradition has been European and Latin American surrealism, with its legacy of found objects, disconcerting juxtapositions, and complex imagery deriving from fantasy, dreams, and the unconscious. Artists as diverse as David McManaway, James Drake, Santa Barraza, Bert Long, and Harry Geffert have absorbed the lessons of surrealism and have produced bodies of work that transcend historical influence and express each artist's most private vision and most personal concerns.

There is still much work to be done in this state to assure Texas artists the critical and financial success they so richly deserve. We need regional art publications to stimulate discussion and criticism, a broader base of perceptive art collectors to invest in contemporary Texas art, and increased support for women and minority artists so that their art can flourish and be equally represented in volumes of this kind. In the meantime, I am pleased and honored to have been asked to select the work of fifty of the best artists working in the state, men and women who possess the ambition to pose new problems, the courage to attempt new solutions, and the conviction that art can and should make a difference.

A Note from the Photographer

If one is a portrait photographer, it helps to be interested in people. It helps even more to have interesting people in front of the camera. This was certainly the case when I photographed Texas artists. They are exciting, alive, thinking, and feeling people who helped me make their portraits.

We always talked before I photographed so that we could get to know one another. When I included family members or pets in the pictures it was because they were an integral part of that person.

As with all my portraiture I wanted to make pictures that would record my subjects' physical being and also, through physiognomy, relay some impression of their inner selves. What is different about these photographs is that I found myself influenced by the work of the artists and often made portraits that show some hint of their own pieces.

For the photographs in this book to be successful the artists had to give of themselves. They did.

50 Texas Artists

Santa C. Barraza

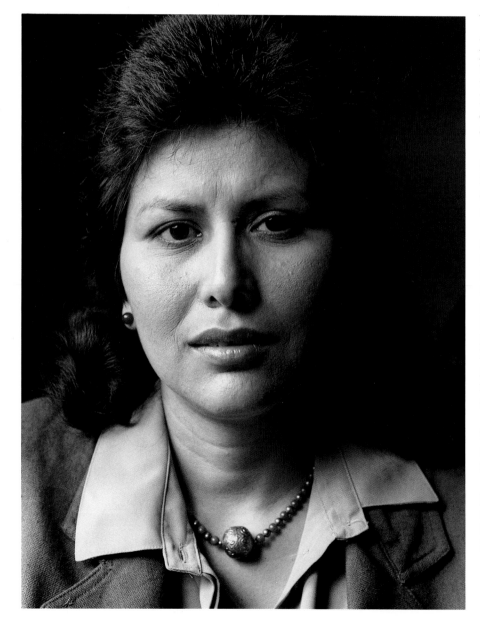

I became seriously involved with art as a result of the Chicano movement, as part of a group developing Chicano art in the Southwest. Modern Mexican art and the "Big Four" (Orozco, Siqueiros, Rivera, and Tamayo) as well as my culture have influenced the development of my work.

My work has gone through phases— art as social-political statement, and an interest in the unconscious through exploration and exploitation of dreams, and now the fusing of the two concepts.

My creativity comes from emotion. And emotion bonds me to Texas, to the terrain, my family and five generations of ancestors—Karankawas, Apaches, Caddos, Spaniards, and early Mexican colonists. I am the product of intermarriage, a mestiza. My grandmother, Cuca Giza, a Karankawan Indian who married a Spaniard land grantee, passed on her determination to me. Determination and perseverance come forth in my work as energy.

In viewing my work, I hope that the viewer will experience that energy that I attempt to capture in my work, and maybe, for a moment, transform.

I work small, mostly mixed media on paper. I use universal motifs such as folk art to express spirituality. My recent work has shallow space and in many instances fractional representation.

Untitled
prisma pencils, gouache, pencil, 1983
13″ by 20″

David Bates

Art history is a good friend of mine. I still feel more comfortable and akin to the old dead guys than any contemporary artist, movement, or "ism." The baroque period is particularly inspirational—the wild hunt scenes of Rubens, the red-faced portraits of Hals, and the vast Spanish still lifes with a full menu of food and game complete with thieving cats and proud hunting hounds ... supply me with true and complex dramas for painting.

Texas has been a great place for me to grow up and be an artist, thanks to predecessors like Otis Dozier and Jerry Bywaters who stayed around Texas to follow their artistic needs without constant reassurance from New York, and to Roger Winter, who was a strong influence when I was in school at Southern Methodist University.

I've lived in New York and visit there often, but do not feel dependent on the city for my images or angst. I get quite a few of both right here in Texas.

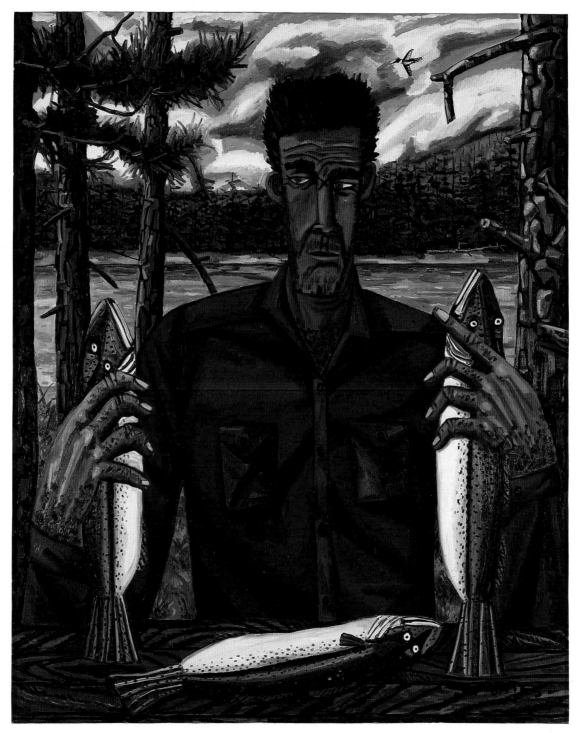

Kingfisher
oil on canvas, 1985
96" by 78"

John Biggers

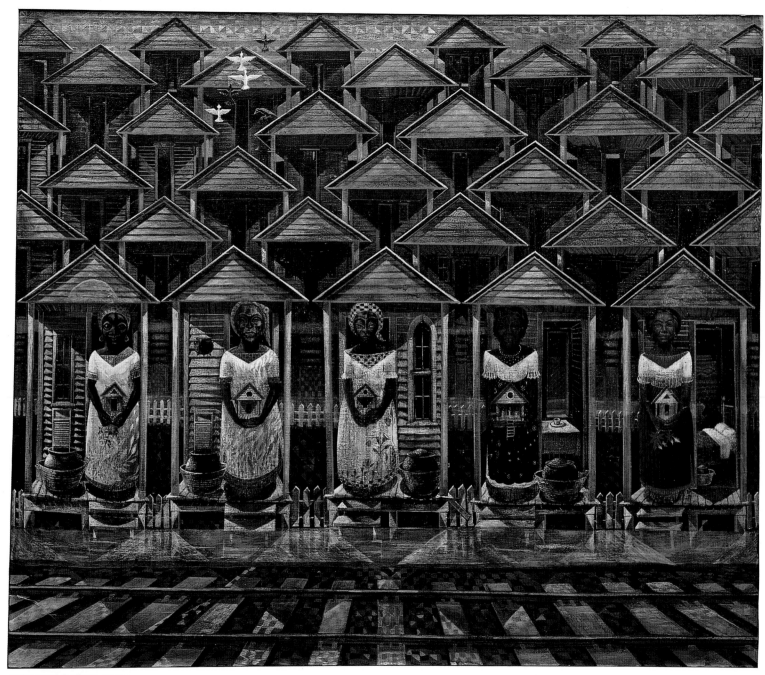

25th Precinct, 3rd Ward: Houston
mixed media, 1984
42″ by 50″

To react to the environment and to do it in terms of the African-American's wonderful way of expressing his struggle to rise above the mundane, especially through his music, Negro spirituals, jazz, and blues, is what I hope to express visually.

My immediate passion is to draw, paint, and sculpt. I am not interested in trends; to me art is the expression of one's soul and human spirit.

My art has always honored the role of women as equal partners in the struggle and celebration of life. My painting of Hazel's garden is a symbolic gesture of the nurturing and synthesis of nature, art, and humanity.

Craft and technique are developed through the struggle to express spirituality.

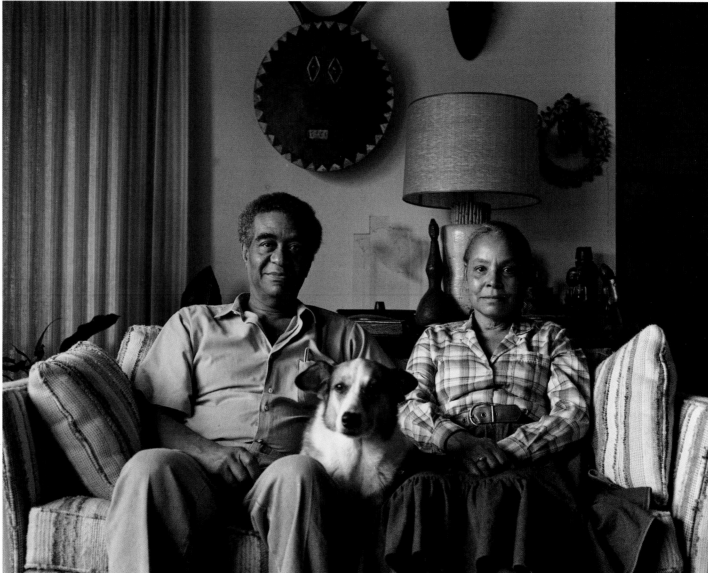

Ed Blackburn

I don't remember when I began to do art. I suppose with me, kid's art just carried over. The influences are so many it would be difficult to list them. When I was eight or nine I used to look at a reproduction of Picasso's *Girl before a Mirror* in a *World Book* my parents had. I didn't know what to make of it. Growing up I drew a lot. I went to movies, looked at comics, and occasionally noticed a book illustration. The latter never seemed that interesting. I still have a paperback on de Kooning that I bought my first year in college. His work seemed so serious and daring and also funny. Influences now seem pretty divided between past art and what's going on at the moment.

For me, subjective communication, technique, and facility run a distant second, third, and fourth. Making art is a world of edges and balance.

Painting No. 5
acrylic on canvas, 1984
73″ by 94″

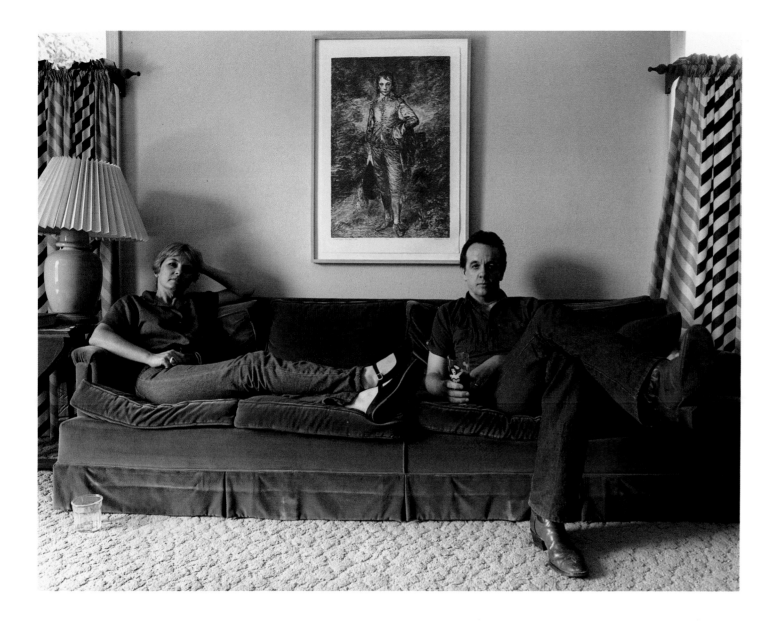

Derek Boshier

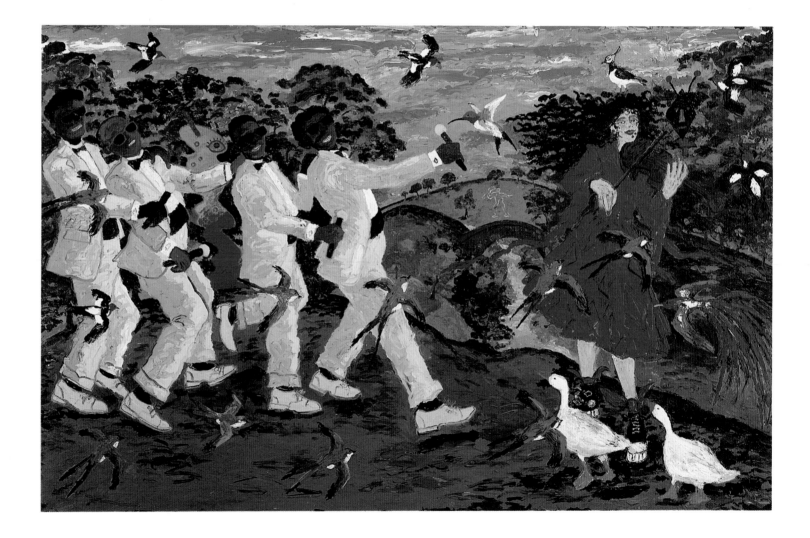

Busy in Paradise
oil on canvas, 1984
88″ by 138″

So many things shape the work an artist produces. Living in Texas? Yes, to some extent; Houston is a large city, but it's subtropical and a relaxed place to live.

I travel, go to Europe every year, and that becomes an input.

Then there's the influence of early college art training, which is always with an artist (if they went through the system), whether it's the influence of a teacher or a reaction against one, or the prevailing, predominant concern of the time. Most important is life itself; my sources tend to be current events, personal events, social and political situations, and a sense of place and places.

I think the two strongest influences for me are trying to make sense of what I do and to enjoy, understand, and make sense of the great painters of the past. Mainly of course by looking, but often by what they said. I've always liked what Degas said about painting: "A painting is a thing which requires as much knavery, as much malice and as much vice as the perpetration of a crime. Make it untrue, and add an accent of truth. The painter never paints what he sees, but what he wants other people to see."

Understanding the process of painting can come from any source. I recently listened to a World War II general, talking about making plans for a battle and how the plans always change in battle. He said, "A plan for war is a plan for change," and I thought—just the same as in painting.

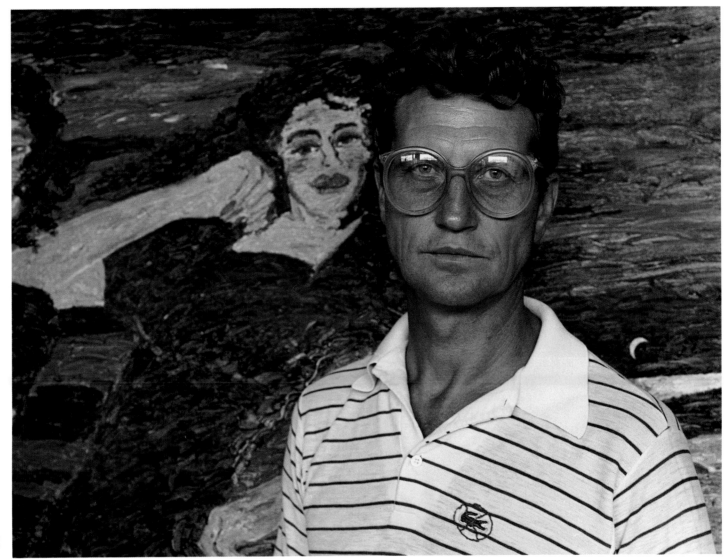

Bob Camblin

some \/\/ say

" PICASSO sed.

Paintings are not
to decorate the
Walls of a
room or apartment,
BUT are instruments
of WAR AGAINST
BRUTALITY and
DARKNESS... "

STOP, LOOK, listen

Sincerely
anonymous

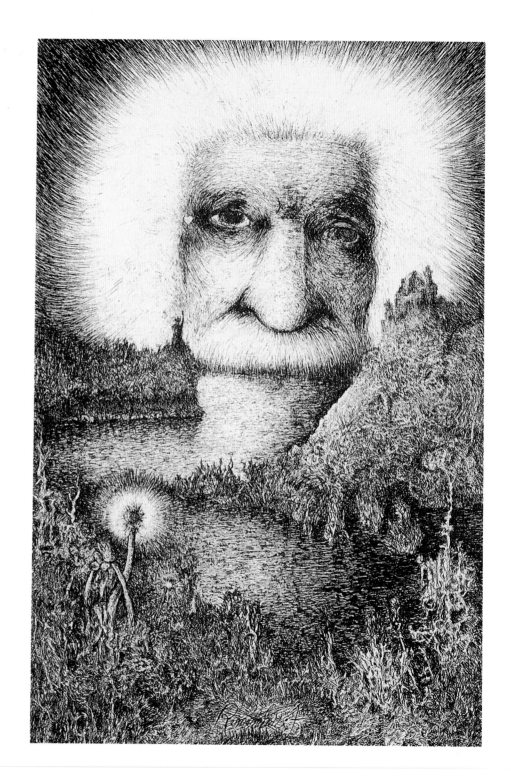

28

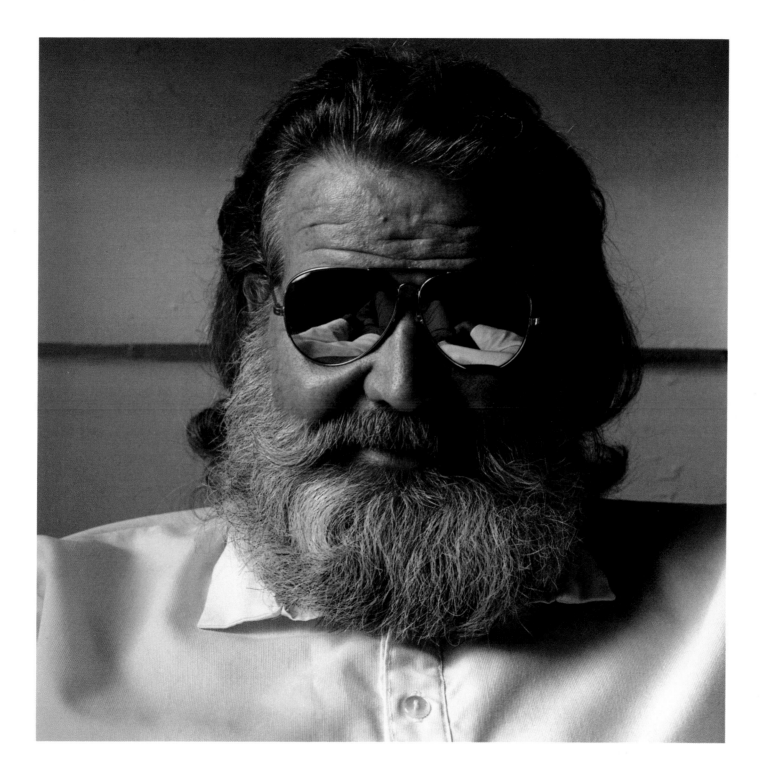

Big Al—April Proof
etching, 1985
12″ by 8″

Mel Casas

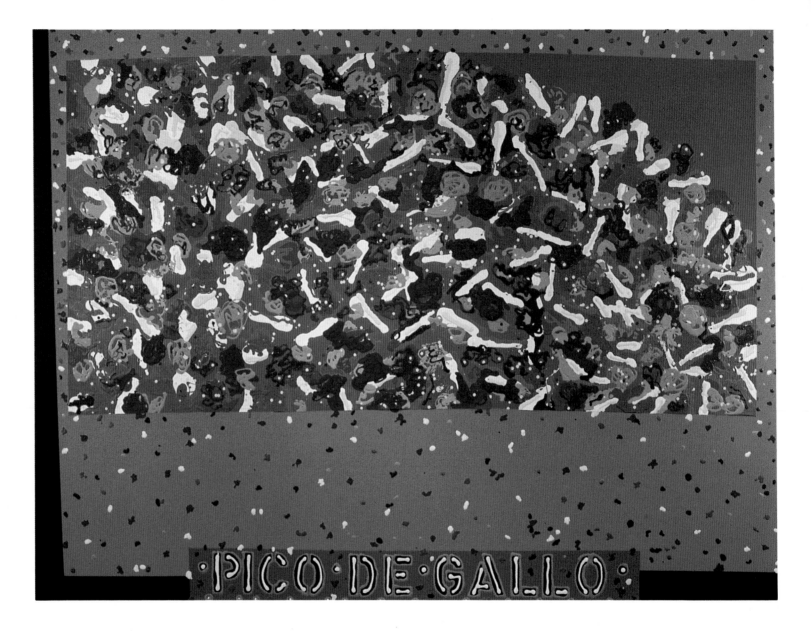

Humanscape 136
latex on canvas, 1984
72″ by 96″

Art As Language:
Art of the Southwest
Art of the Border

On the Border of What?

1. fringe art
2. marginal art
3. ornamental art
4. art on the verge
5. art on the brink
6. art on the rim
7. art of the ethnic minorities

Compound Question by Compounding Border into Borderline

1. borderline art
2. intermediate art
3. in between art
4. not quite average art
5. marginal validity art

Do Negative Word Factors Produce Negative Image Responses

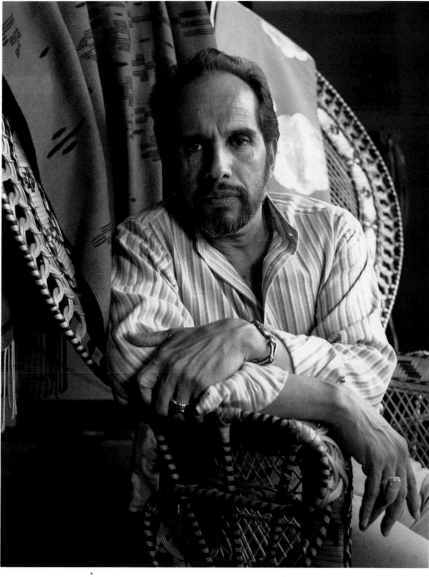

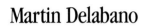

Martin Delabano

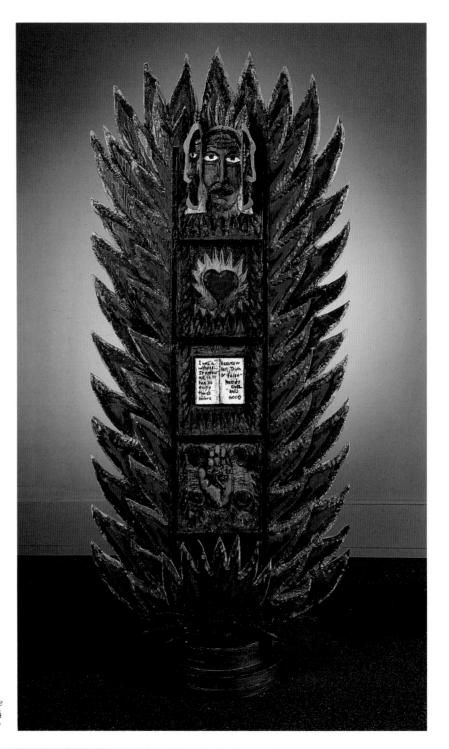

Flaming Ladder Stele
acrylic on wood, 1984
82″ by 36½″ by 16″

I am a daydreamer; I see visions. These visions express a layering of ideas which weave together into the textural narratives I give form through image-making. I am procreating modern arche-types, which are not about truth, but about a searching for enlightenment. In a world that sometimes seems void of any personal spirituality, I'm trying to invoke a referential association between the viewer and the elusive soul.

Any one of my pieces is generally made of many different materials. In a sense I try to hide the materials so they will not distract from the illusion of the image. This helps to heighten the psychic space or presence the image projects so that the viewer can enter into the piece more readily.

People are often surprised when they meet me. They are not expecting a gringo with a master's degree in art. My work may have a primitive feel to it, but I know too much to be a primitive. My whole life has been one big art-history lesson. I grew up in a house full of art and my father, Barney Delabano, works at the Dallas Museum. Having grown up in that type of environment, I got to meet many different artists and see a vast array of art. My parents also took me on trips to Mexico and Italy to see museums, churches, and archaeological sites. But my primary influences are my grand-father Taylor, whose tools I use and feel his presence through, and my father, whose figurative paintings directly influ-enced my own need for figurative repre-sentation. These and all of life's experiences are the root of my work.

James Drake

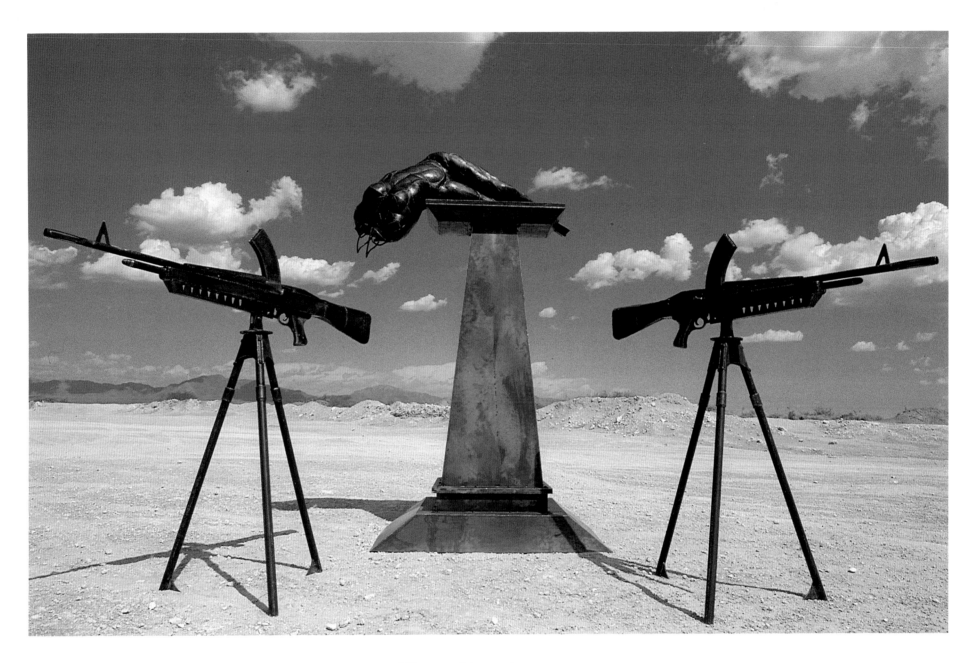

Praetorian Guard
steel, 1985
96″ by 96″ by 88″

For me sculpture must assume a personality, character, and life of its own. I try to make my own work as exciting, powerful, and thought-provoking as possible.

Vernon Fisher

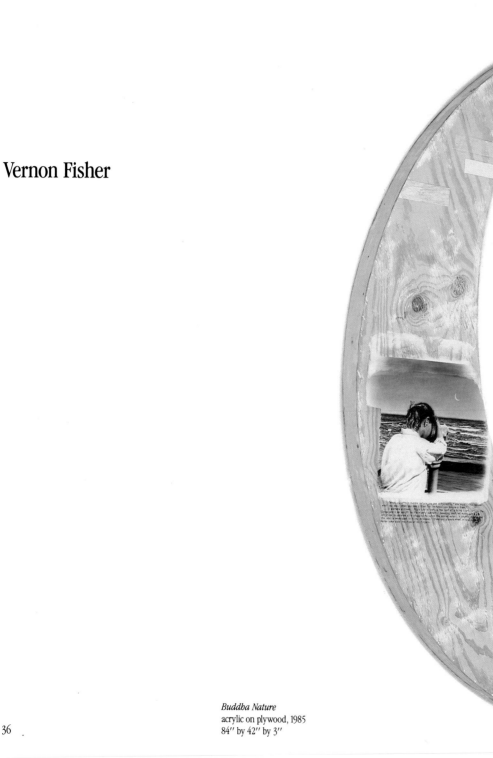

Buddha Nature
acrylic on plywood, 1985
84" by 42" by 3"

I am Buddha Nature.

"When you attain Buddha Nature you see differently," she says. "You become what you see. When you see a tree, for instance, you become a tree."

I picture a river. Rigid and silver in the last of a dying light. It is the Ganga and I am adrift in its mighty current. Sweeping past red muddy banks and pilgrims in colored silk stooping to catch the sacred water. A shutter closes and the sky is enveloped in a filmy darkness. Stars and planets wheel wildly overhead. Asian carp suck the tips of my fingers.

Roy Fridge

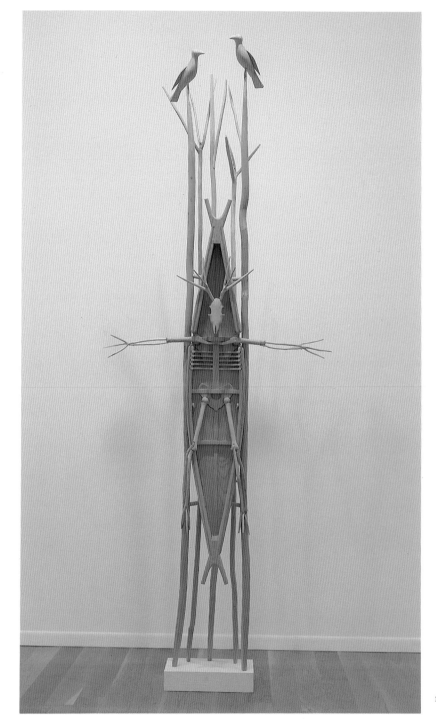

I am a Romantic in the nineteenth-century sense of Henry David Thoreau or Paul Gauguin. Gauguin ran away to Tahiti. I ran away to Port Arkansas, Texas. In a narrative commenting on my semi-isolated life I wrote: "The only difficulty I've found in being a hermit is being all alone." I view life and living as a journey—a voyage of discovery. It is also extemporaneous theater and my art works are symbolic sets and props used to describe that personal drama . . . that voyage.

I have lived the life of an "amateur hermit" and I have used the shaman as persona—as psychopomp psychological voyager into the uncharted darkness of the unconscious. The boats, the shrines, the narratives reflect that journey—sometimes actual, sometimes imagined, but always real.

The Voyage of Initiation
mixed media, 1984
118″ by 43″ by 14″

Harry Geffert

My One Horse Marketplace Museum
bronze, 1984–1985
69'' by 69'' by 69''

To me art is a vehicle for learning. When I recall my childhood experiences, I seem only to remember how I felt. I grew up in the country and at the age of five, or so, I went to sleep on the back of "old Jersey," our milk cow. It was just about dark and almost cold. When I awoke, I felt cheated. I wanted more of that feeling; the feeling of warmth, the smell of Jersey, the almost but not quite cold air and the total sleep. It was a perfect experience.

I went back the next evening, climbed up on top of Jersey, laid my head on the flat of her shoulder, closed my eyes, and tried and tried to reclaim that feeling, but I never did.

If I were to divide myself into two parts, one half would belong to this sensory side and the other would belong to a learned, logical side. It is with my senses and logic that I confront my work. I feel I have the skills to make most anything my senses require. I make most of my decisions on this sensory level, almost in a dream state. Like a dream, it might all go away, so there is an urgency or a drive to get things done before I awake.

I seem to think in little moments and I combine one moment with other moments. The content of the work is established by a general direction which is influenced by these little moments. In the back of my head is a scheme for the architecture and the mechanics. Simply stated, all these factors, the content or the direction, the architecture, the mechanics, and the materials and processes make up my aesthetic. All these factors allow me to give and take, to adjust and change right up to the time a work is finished.

I make art because I want control over the learning process which is life and which is art. I want what I can't have in a dream or in today's real world. The only time this control seems to be possible is when I am in my studio. I feel I am cheating on life or being cheated by life when I am not in the studio or recharging my sensory batteries. If I knew before I started what the outcome would be there would be no necessity for making art. Likewise, if I knew what life held, there would be little reason for living.

Joseph Glasco

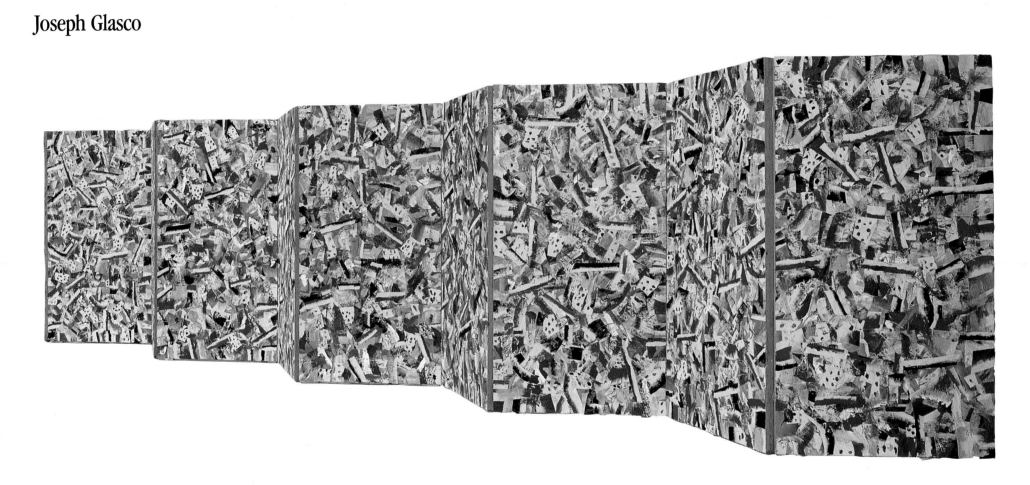

Untitled
acrylic on canvas with collage, 1984
10 panels, 88″ by 48″, painted on both sides

For me art is about art and also about life. If a painter has searched and found something of value in each and draws from those, then the artist may one day fuse the two and make his own private world.

("Make your days like your nights")
—Andre Breton

Linnea Glatt

My work is done out of a need for personal resolve. At the same time, I want my work to be mindful of shared human needs.

A Place to Gather
concrete and cedar, 1982
96″ by 240″ by 168″

Joe Guy

Waiting. Listening.
 The Works are about a mood.
It is the mood I bring to the work.
The mood pervades my awareness
and is framed by this:
having nothing to say, one says that.
And yet, hidden in this saying is a hope.
 That
in the saying the unsaid will reveal itself.
("Art is not about knowledge. It is the
 depository
of the unsaid." Avigdor Arikha)

In *this saying* of nothing, restriction of
 content
is a means
to the point where the Work exists on the
 boundary. There
risking being an anonymous thing or
clearing the way, in its presence
for the unsaid.
Better to be an anonymous thing
than to be about saying something,
for the saying of something, in its
 calculating, conceals.
Meditating one thing clears the way
for the unsaid.

And what of the Sayer
in *this saying* of saying nothing,
in restraining from saying something.
Where does He stand?
He stands in his Truth, aware
that the saying of something
is too great.
His Truth too, as in the Works
is in the waiting
for the unsaid.

Beauty Arrests Motion
stretched paper, paper hinges, graphite, wax, 1985
86″ by 264″ by ¾″

John A. Hernandez

My earliest influences were seven art deco theaters in a radius of five blocks that showed predominantly horror movies, comedies, and Mexican Westerns. I remember once leaving the theater and seeing my grandmother with an old woman with a large cancerous sore on her head. This woman was always begging for money among the winos and families and cantinas.

I care about a lot of things—humor, people, freedom, fun, absurdity, newspapers, tabloids, earth, and the heck with the respectful establishment even though they are the ones that acquire the art.

I work from memory of magazines, comics, and political events, all from the point of view of a couch. From this couch, I try to bring something tough into view, some sort of insanity in all this respectability of fine art. I also try to make it like the horror movies I used to watch.

Home was created from memory with the idea of the home front, patriotism, the medical quack, escape with a car, still lifes, and all else that comes to mind. My new work will get closer to the horror movies and madness and insanity. Instead of mimicking the *Enquirer* or life down the aisle at Woolworth's, I will stick to the big screen.

Most important is getting a cartoon to look convincing and hopefully to create a mirror into the fun house.

Home
mixed media, 1985
75″ by 32″ by 7″

48

Dorothy Hood

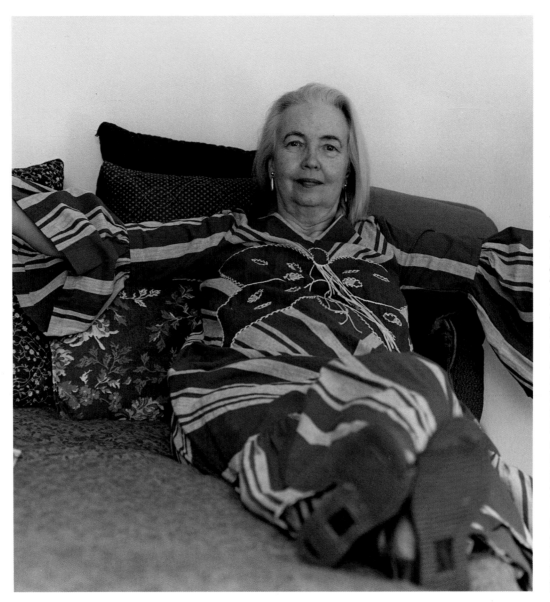

I like to think that there are destinies in things. That whatever led me to Mexico, to become aware of Mexico's color and humanity, led me likewise to Texas—as though the space in Texas was necessary to being alive, and then to express it in paint as one of the driving forces in my work. Experiences flash together, impressions so vivid that they seek release on canvas, and in drawing from the psychological traumas of life's blows, all works toward an art of such intensity that allusions are born. One feels as though shot off from the earth so as to glimpse it from the time and distance of another planet, and surprisingly, to find oneself at the same moment in Texas at the birth of the space movement.

I think of my work as the putting together of many plateaus, but more so of peeling away whatever might obscure my truths. My process is never to add unto, but to peel down to essence. Yet it has been called surreal abstraction.

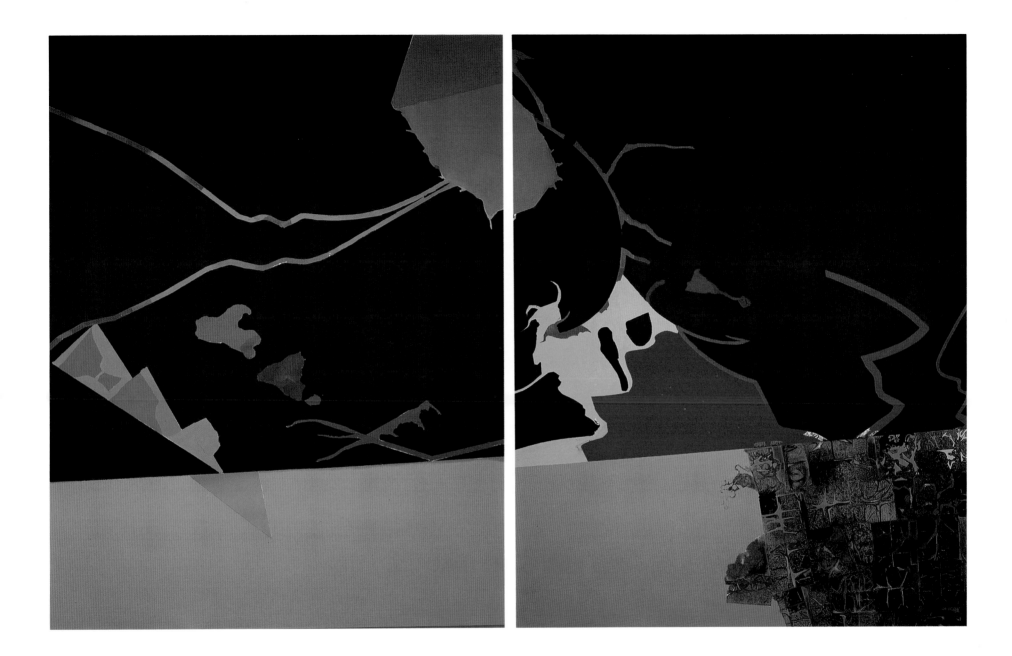

Halley's Comet
oil on canvas, 1985
240″ x 192″

Luis A. Jiménez

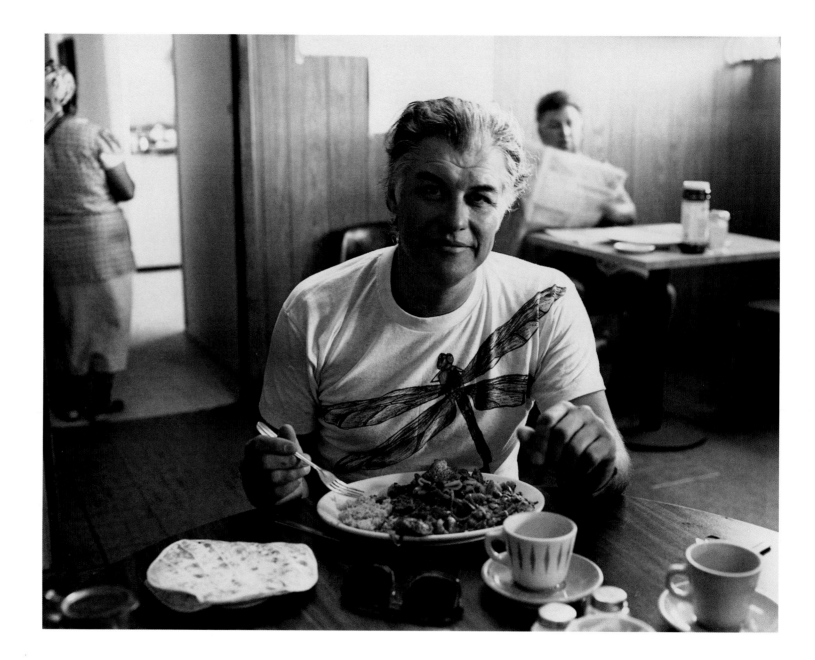

My main concern is creating an "American Art" using symbols and icons. Sources for the work come out of the popular art and aesthetic (cowboys, Western Indians, the Statue of Liberty, motorcycles). As does the material—plastic (surfboards, boats, cars). I feel I am a traditional artist working with images and materials that are of "my" time.

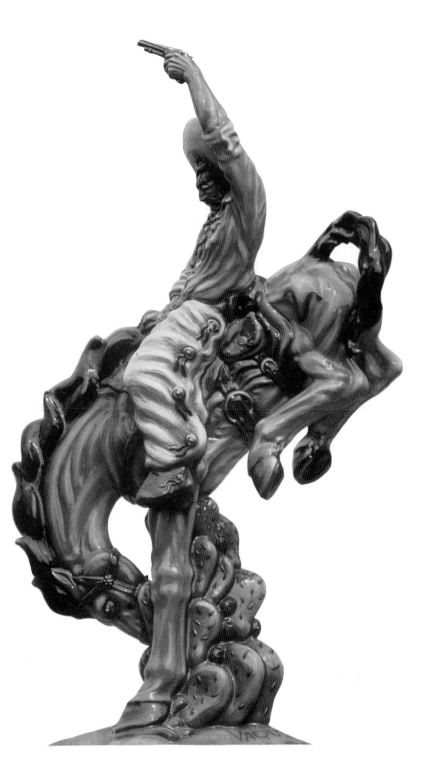

Vaquero
fiberglass, 1980
16 ½ ' (height)

Thana Lauhakaikul

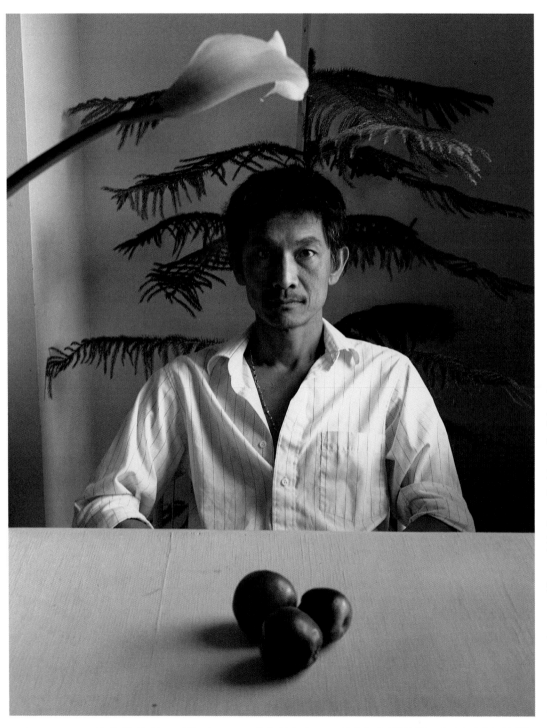

I have been influenced by my mother and the rivers where I was born in Thailand, surrounded by nature—mountains, forest, plains, rivers, and oceans.

I have nothing to care about in my life. It is complex as much as my work is complex.

The infinite dimensions of the fourth-dimensional concept are most important in my work. I make art solely for love, balance, and to explore my true nature.

I have done interesting work when my spirit was of balance.

I like to travel to my homeland.

Artists I've admired are Albert Einstein, Leonardo da Vinci, Amedeo Modigliani, Vincent van Gogh, David Smith. I read physics, astronomy, early Greek philosophy, and spiritual books.

My family is in my heart. Living in Texas is just my way of life.

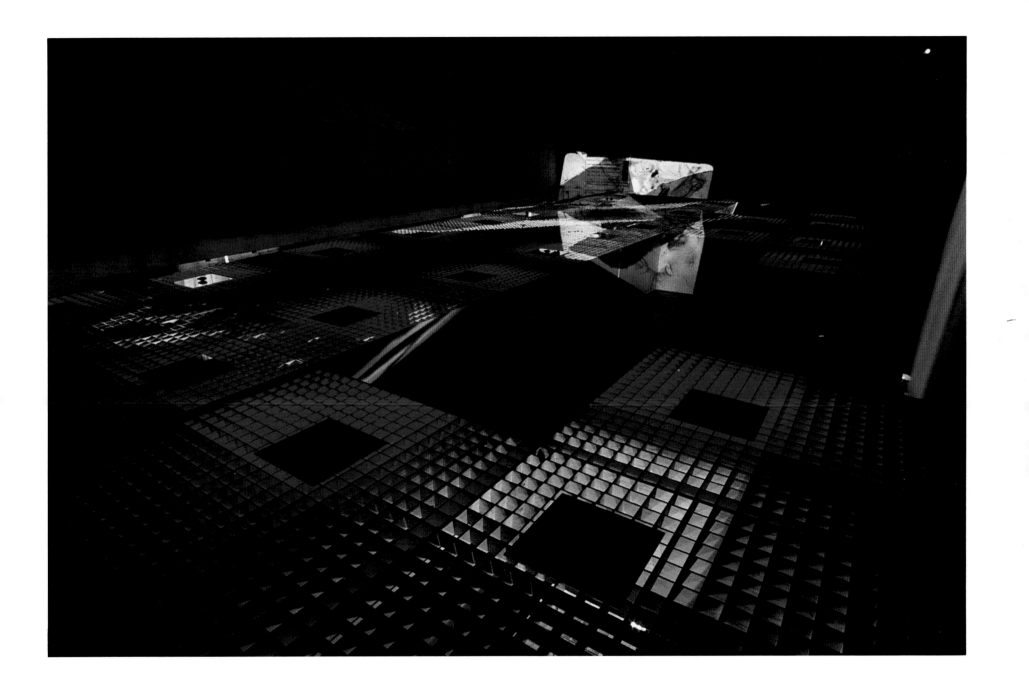

Celebration
Mixed-media installation with projected light and sound, 1983–85
36″ by 192″ by 300″

Robert Levers

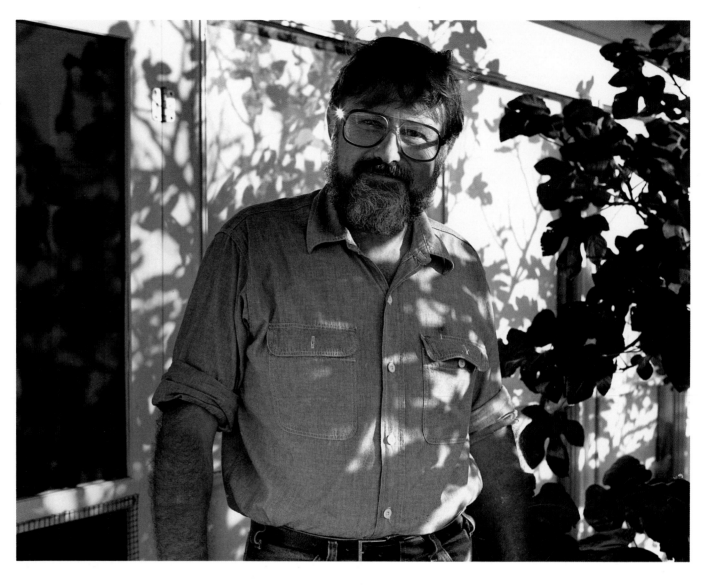

I paint to find out what I think and feel. The nudge that starts the process can be a facial expression, a human gesture, the way a particular light falls on something interesting, a dream, or even a casual remark that turns into a mental slide.

The work always has a layer of humor, I notice, even when the nominal subject is dead serious. I prefer not to consider this a limitation but instead an opportunity to make the picture richer. I know I'm done when all the shapes are dancing to the same music.

I hope I live long enough to paint almost all—God forbid absolutely all—the pictures I think I can feel behind my forehead.

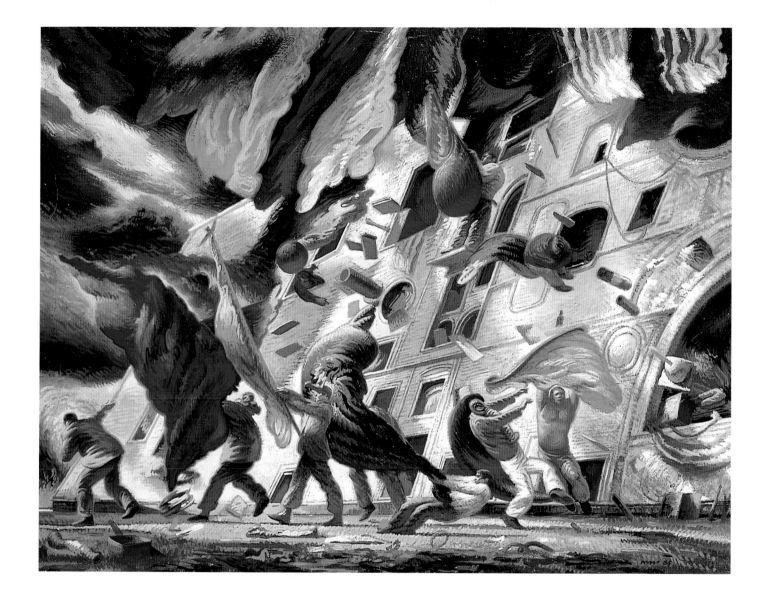

Practicing for the Half-Time Ceremonies at the Burning Stadium
oil on canvas, 1985
18″ by 24″

Bert Long

ART, LIKE TIME, NEVER STOPS

Art is...

125,000 years ago	Neanderthal man.
25,000 B.C.	Cave art.
2000–1501 B.C.	Earliest beginnings of the building of Stonehenge, near Salisbury, Wiltshire, England.
1000–901 B.C.	Brush and ink painting in China (lacquer painting practiced since early ages).
30 B.C.–124 A.D.	Building of the Pantheon.
535 A.D.	Earliest Chinese roll paintings in Tun-huang (landscapes).
651–716	Li Ssu-Hsun, Chinese painter.
1408	Donatello: *David, St. John* (sculptures).
1452–1519	Leonardo da Vinci, universal genius.
1471–1528	Albrecht Dürer, German artist.
1495	Hieronymus Bosch: *The Garden of Worldly Delights.*
1563	Pieter Brueghel: *Tower of Babel.*
1629	Peter Paul Rubens knighted by Charles I.
1760	First exhibition of contemporary art at Royal Society of Arts, London.
1820	William Blake, illustrations to the Book of Job.
1844–1916	Thomas Eakins, American painter.
1845	First artistic photographic portraits by David Octavius Hill.
1845–1926	Mary Cassatt, American impressionist painter.
1853–1890	Vincent van Gogh, Dutch painter.
1865	Yale University opens first Department of Fine Arts in U.S.
1880	Rodin: *The Thinker* (sculpture).
1881–1973	Pablo Picasso, influential and controversial Spanish artist.
1886–1957	Diego Rivera, Mexican painter.
1889–1975	Thomas Hart Benton, American painter.
1901–1966	Walt Disney, film producer.
1904	Salvador Dali, Spanish painter.
1909	Francis Bacon, Irish painter.
1912–1956	Jackson Pollock, American painter.
1912	Armory Show introduces postimpressionism and cubism to New York.
1914	Romare Bearden, American painter.
1925	Robert Rauschenberg, American artist.
1930	Grant Wood: *American Gothic.*
1939	Grandma Moses (Anna M. Robertson Moses) becomes famous in the U.S.
1940	Bert L. Long, American artist.

"When I get to heaven I mean to spend a considerable portion of my first million years in painting."

Sir Winston Churchill (1874–1965)

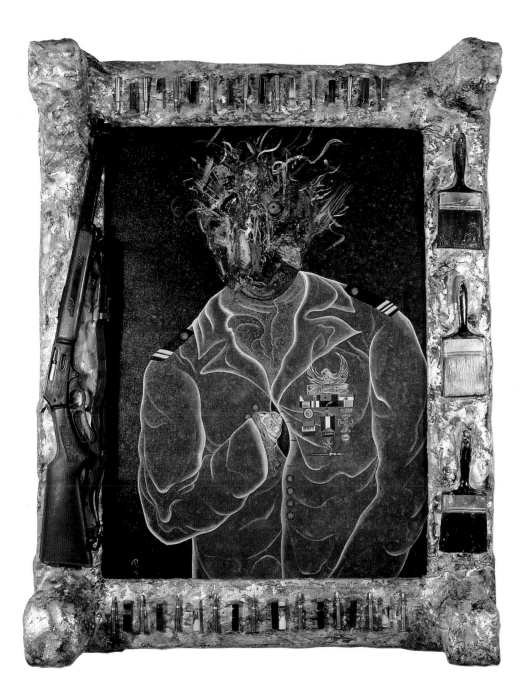

Artists
acrylic on canvas with collage elements, 1985–86
52″ by 42″

Jim Love

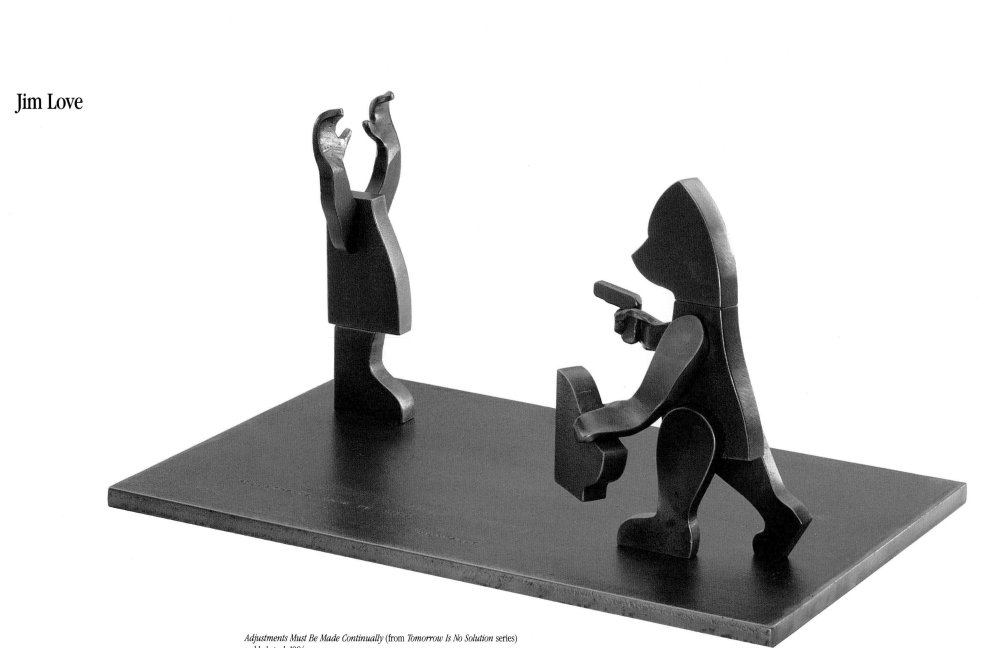

Adjustments Must Be Made Continually (from *Tomorrow Is No Solution* series)
welded steel, 1984
7″ by 13 ½″ by 8 ½″

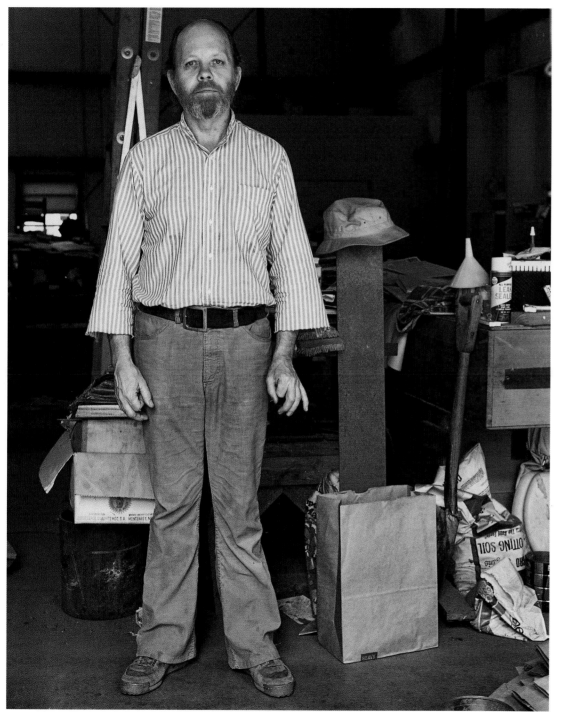

A good part of the mental or emotional rush (it is hard to know which) that is one of the immensely positive factors in the process of making art, can come from the sudden occurrence of the unexpected. In order to experience that rush, we must be enormously prepared and totally receptive, so as to be able to run with the surprise and make it work.

It is essential to keep working on some continual basis. Being at work provides the best climate for discovery. Waiting for ideas is waiting for ideas.

Most of us continue to insist that we do our work primarily for ourselves. And this I think is basically true. We do it to bolster our inner selves and to hold on to our confidence. We do it to test our imagination. And part of the time we do it for the risk. We never know how something is going to turn out. The whole process of making art is surrounded by not knowing. That is the gamble and the challenge that we seem to want.

William Jackson Maxwell

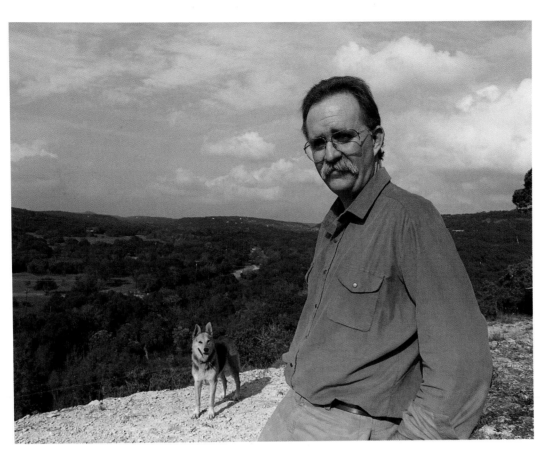

Now, that spirit of a child, engulfed, timeless, totally submerged in the moment of work and play, is what I try to keep in touch with. I pursue whatever takes me at the moment, knowing that eventually all this seemingly schizophrenic behavior will provide a hybrid of sorts. Focusing a magnifying glass on one point, trying to blend science, personal mythology, and a dash of magic, constantly shifting back and forth from technical and scientific to playful and abstract, this is my way to resolution.

In all of this I hope to find a revealing pattern. So far the patterns are as baffling as a trace of a subatomic particle from a bubble chamber. But I manage to retain a sense of infectious purpose pursuing what cannot be seen, only sensed—hoping that the models I make will always leave something just out of reach but tantalizing enough to chase.

I was born in 1947 in Auburn, California. One of the most important events of my early years occurred in 1956 when I began my first passage to China in our back yard, which happened to be the Sierra Nevada Mountains. Twenty-one years later another significant event occurred. I started my second passage to China in the spring of 1977 at Red Dog, California. In a special way this event symbolized the rediscovery of a very important aspect of myself and proved to be an invaluable resource for making sense of my art.

What I have tried to foster is the blind faith that I had in reaching China. But most important, and even though China was the goal, the dig was what was essential. Every spare moment stolen from school, work, and all my Saturdays was devoted to that hole. Somewhere in the work was the secret to the mystery. Sensing was all I had; seeing would take time.

Installation detail—*Target Photon Spheres and Target Photon Drawing*
spheres: Fiberglas, paint, pencil; drawing: enamel paint on paper, 1984
spheres: 40″ diameter; drawing: 72″ x 252″

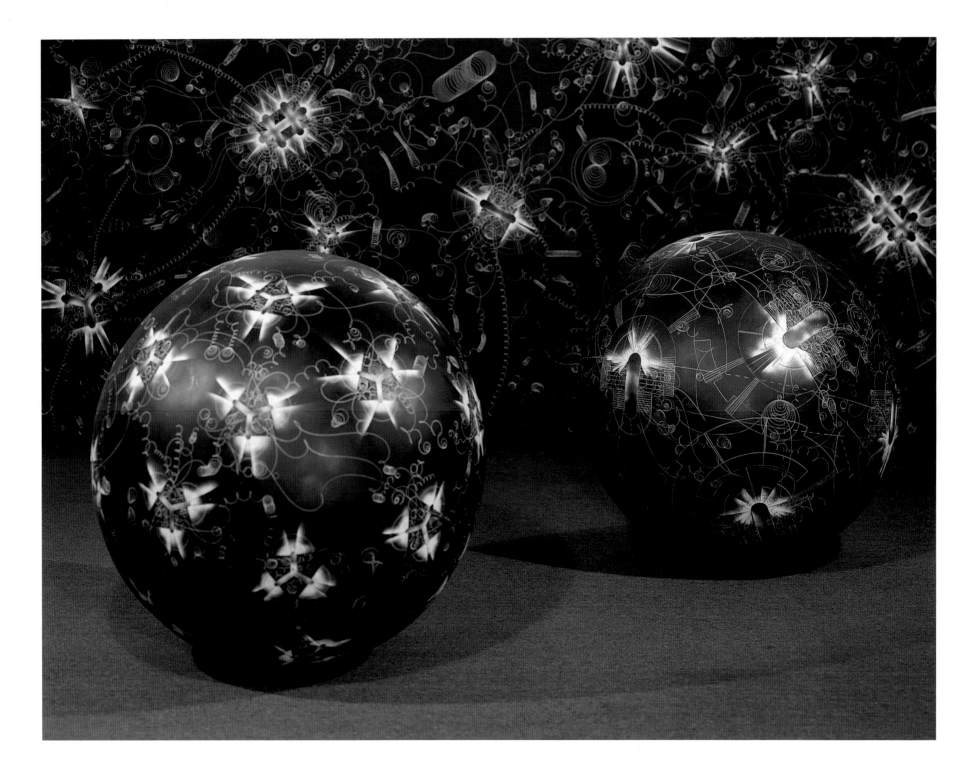

David McManaway

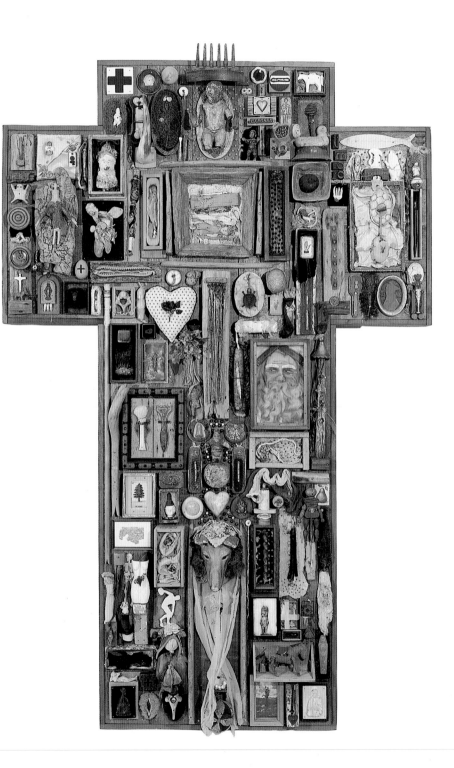

The Cross
mixed media, 1978
81 ½ ″ by 54 ″ by 12 ″

Found 1981, in M.F.K. Fisher's *A Cordial Water:*
 "He went through the wet wild woods, waving his wild tail and walking by his wild lane. But he never told anybody."—Rudyard Kipling

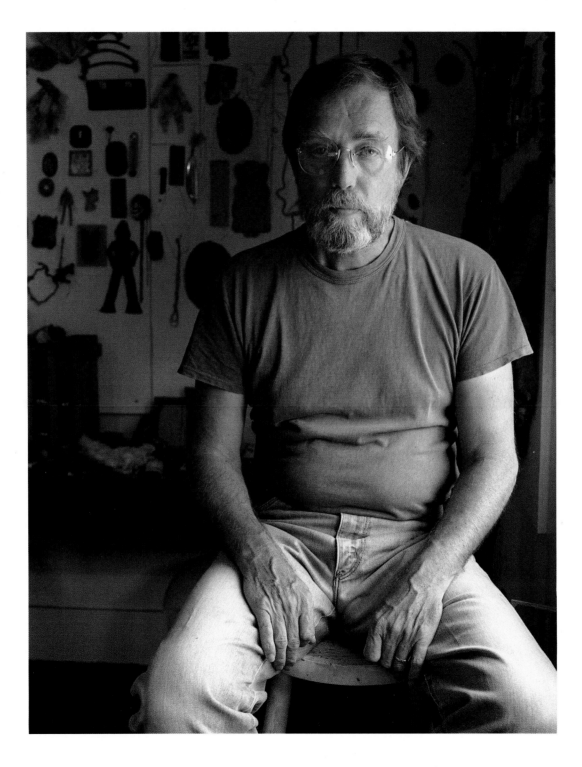

Melissa Miller

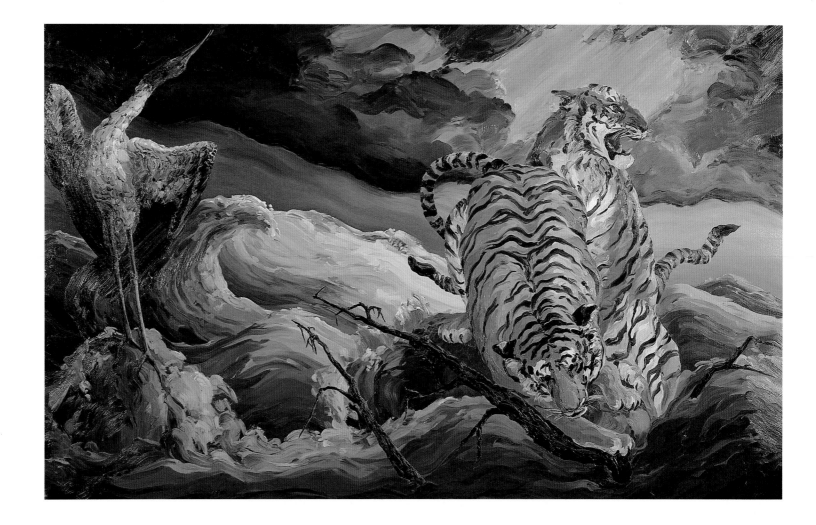

Flood
oil on linen, 1983
59″ by 95″

Thematically, I wish my paintings to depict the many facets and layers of life and survival, of which I am a constant and curious observer. My abstract concerns demand that the painting be treated, while in process, as a changing, living organism, and that the brush-strokes themselves ultimately serve as both form and content.

I have always shared environments with many animals—from livestock to household pets. Using them as actors and symbols in my paintings has seemed only logical. Presently, my constant companion is an old, sweet, white-muzzled hound. We usually know what the other is thinking.

Jack Mims

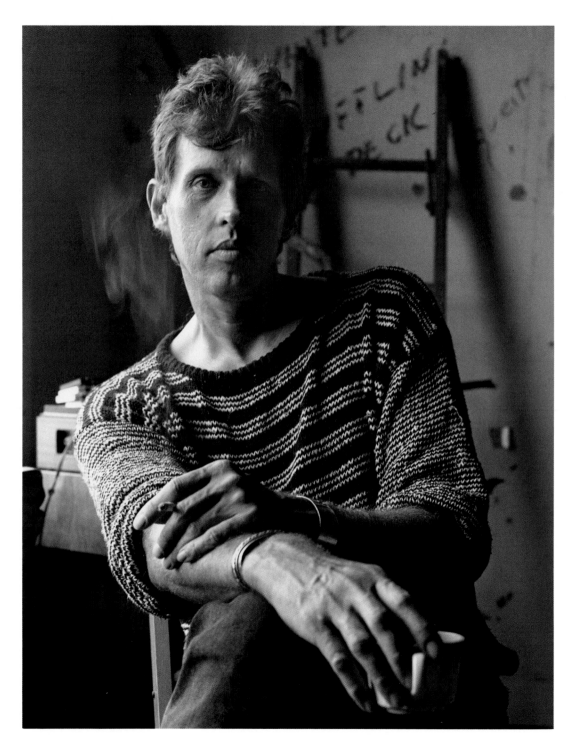

I have two close friends who live in Fresno, California (they are really from Texas), a husband and wife, both artists. Last year at about this same time (this is October, 1985) these two people, myself, and many of our mutual friends were in Austin for some occasion, and before departing our separate ways we all met for breakfast. Somehow in the intertwining conversations my friends from California asked me jokingly if I had ever in my life done a small painting. I had. I said, "Yes." She asked if she could have it. I said, "Yes." But I forgot to send it for a while.

He was back in Texas about a month later and came to my studio for a big Bar-B-Que dinner, at which time I showed him the smallest painting I had ever done. It was called *Stagefright at the Country Dinner Theatre.* Shortly after he returned to California I shipped the painting to them (really to her since she had been the one who asked for it so bluntly).

She was born November 2, the Mexican Day of the Dead. *Under the Volcano,* Malcolm Lowry's great novel, takes place on the Day of the Dead, and that book and its author have shaped much of my work in such profound ways. That book and its author also have in one way or another affected my two friends in their lives.

As a gesture of thank-you for my smallest painting he sent me a drawing, which was a portion of David's *Marat* with volcanic smoke and fire spewing from Marat's knife wound at the hand of Charlotte Corday. On the drawing my friend had written, "Jack, this mean gesture is intended as a sincere Thanks for the 'World's Smallest Painting (of a dinner Theatre tragedy).' The following is from

Mr. Lowry's *The Forest Path to the Spring*. . . . I keep it on my wall and read it when I'm trapped (every fucking day!). . .

"Dear Lord God, I earnestly pray you to help me order this work, ugly, chaotic, and sinful though it may be, in a manner that is acceptable in thy sight; thus, so it seems to my imperfect and disordered brain, at the same time fulfilling the highest canons of art, yet breaking new ground and, where necessary, old rules. It must be tumultuous, stormy, full of thunder, the exhilarating word of God must sound through it, pronouncing HOPE for man, yet it also must be balanced, GRAVE, full of tenderness and compassion, and concepts, but let me be truly thy servant in making this a great and beautiful thing, and if my motives are obscure, and the notes scattered and often meaningless, please help me to order it, OR I am lost."

His drawing and Malcolm Lowry's prayer hang on my studio wall and I try to read it every day. I hope my friend does not mind—I want to pass this on.

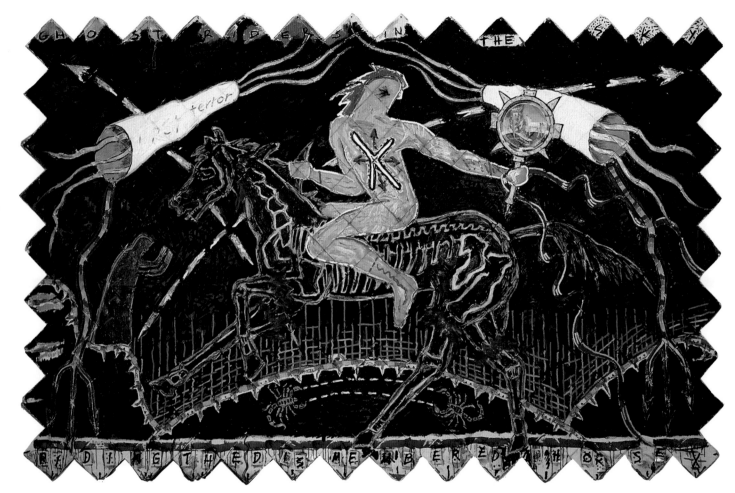

Black Horse/White Horse First Terror Comet Cross
acrylic on canvas, 1985
114″ by 180″

69

Michael Mogavero

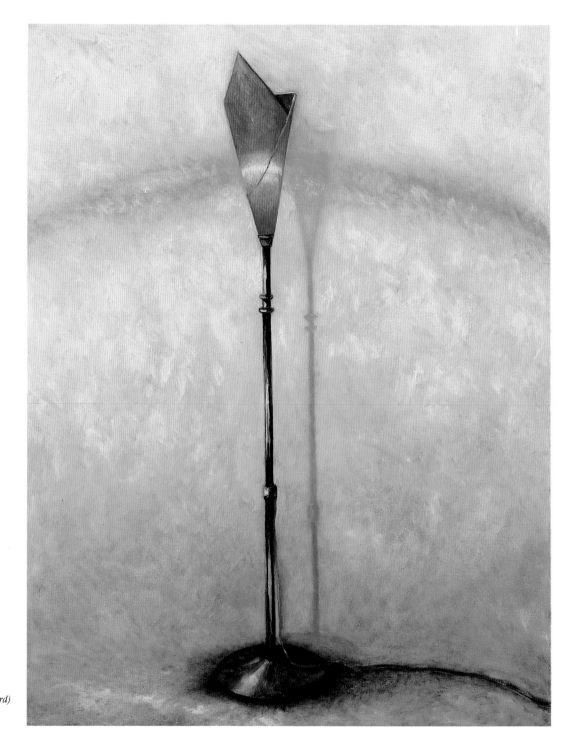

Lite of Spring (Prayer for Edward)
oil on canvas, 1985
72″ by 54″

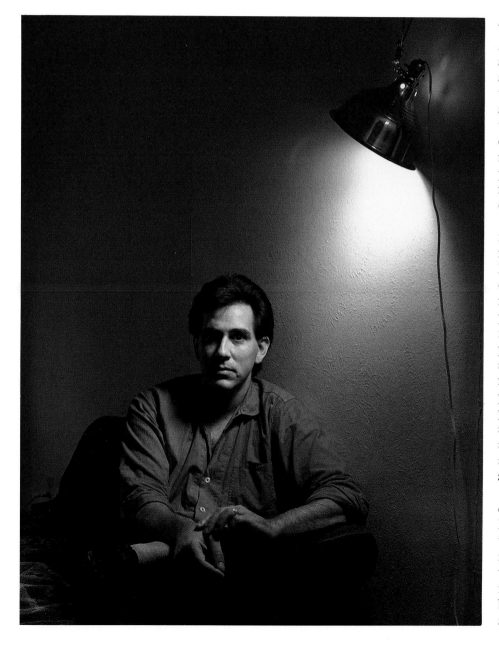

In my late teens I began making paintings long before I realized there was such a thing as art history. As I began to study about art, I became fascinated by the role painting and sculpture played in society and culture in the centuries prior to mediums such as photography, cinema, and television. While I am a child of machine images, my notion of the role painting plays in our culture today is more one of visual poetry than narrative description.

For many years I have had a strong interest in theater and music. It was the magic I think I sensed in stage design and lighting as to how a set made of ordinary objects could become superreal and a dramatic component of the action taking place on stage. In music I believe it is the immediate sensation one gets from composed sound and the dynamics in arrangements which again produced the magic for myself, the audience. Through painting I have found you can be a composer, set designer, lighting technician, and director. The result will not be seen as a narrative script like a play, but more as a series of visual notes producing a sensation or mood from the rectangle.

Recently I have been making paintings containing mostly ordinary objects (i.e., lamps, flowers, tables, etc.). I began to transform these ideas of objects and light into composed images which perform with a heightened sense of drama and illusion. I try to render the sensation believable, thus giving the viewer the same drama.

My historical influences are a lot like Texas, wide open. I have used borrowed and stolen elements from cave paintings on through to video images and *Architectural Digest*. When presented in the right way, any image can be used as symbol or metaphor. For the painter this means putting an expressive idea together within a sense of order to give the viewer the means to feel the magic.

Nic Nicosia

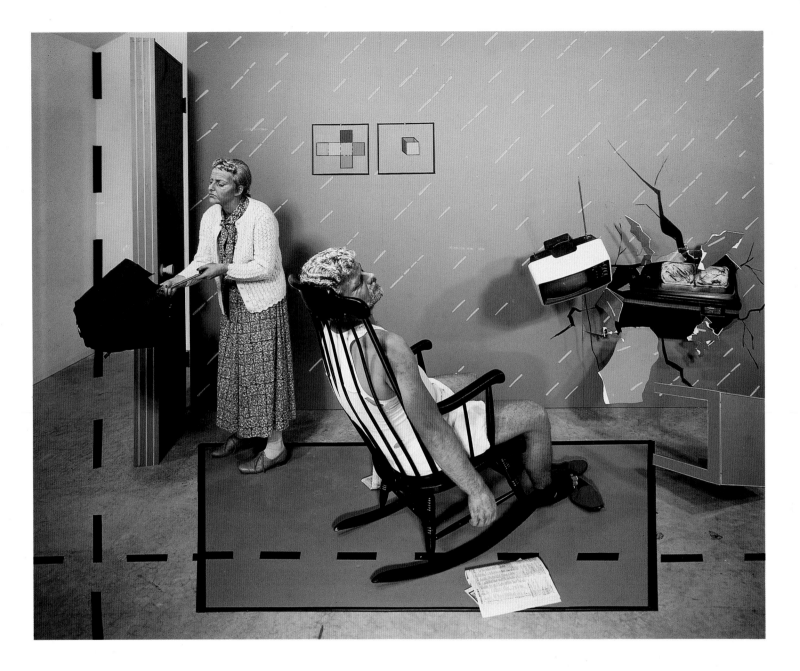

Domestic Drama #7
Cibachrome, 1982
40″ by 50″

Although my formal training was in television and film production, I never really pursued that as my career after many discouraging attempts to land a position as a cinematographer. So after receiving a B.A. from North Texas State University in radio, TV, and film in 1974, I opened a camera shop in my college town of Denton—partly because the town needed it, but mostly because I needed a job, although I knew nothing about business or still photography. I like changes, newness, and something to work on. A few months later I was married, and between then and now have had two daughters.

Well, I kept the shop for five years; it was successful, but it became very boring sitting in that store talking technical jargon. Of course during that time I learned to use all cameras and work in a darkroom, the latter which I don't like at all, and have not stepped foot in for five years. My influences toward photography were the photojournalists; many were my customers. Nikon cameras were it, and the street photograph was the target.

After selling the camera shop I returned to school to receive a newly offered M.F.A. in photography, which I never completed. My friend and teacher was Al Souza, well-known for his conceptual and humorous use of photographs that expose the false information perceived through them. I was presented with a new view, *fabricated to be photographed.*

Ah ha! There is more than the snapshot and the "decisive moment." This was great by me; now I could combine my film-making background, my new-found interest in art, and still photography to create anything I want, any way I want.

Well, my influences no longer came from the Cartier Bressons or W. Eugene Smiths, but from pop artists like Jasper Johns, Robert Rauschenberg, and more directly from Roy Lichtenstein, movies, TV sitcoms, fashions, stories or books I've read, and everyday events and situations of contemporary American life. I began by re-creating an image on a photographic print, with colored paper, paint, pencil, etc. Then I treated an actual site in the same manner, but still ending up with a color photo as the final product. And ultimately, as I am today, I started creating complete scenes in my studio. Now I was making "art"! I was physically involved with the piece! I paint, make objects, costume actors, fabricate sets, create situations, direct, and then, somewhat anticlimactically, take the photograph.

I work best in series. I like combining different situations and actions in one frame. The two series *Domestic Dramas* and *Near (modern) Disasters* define this. Those images were like cartoons, or comics, where anything and everything could happen.

My current series, titled *The Cast,* is concerned with the development of characters. I continue to fabricate a set in the studio, but concentrate on the costuming and makeup of actors. The interest is the "face" of an individual, the way one looks and dresses. This is usually our first and only impression of someone, and one from which we pass judgment.

I want my work to be universally entertaining, provocative, and to create some emotion. By doing this I think the object, person, or situation portrayed will be regarded as being more or less important than we believe it to be.

Madeline O'Connor

Purple Gallinule
oil and acrylic on canvas, 1983
40″ by 207″ by 8″

Although the artistic influences in my life have been numerous, I will mention two—the deeply moving, powerful, contemplative quality of Mark Rothko's paintings and a favorite quotation from Matisse: "An artist must possess nature—identify himself with her rhythm and by that effort he will be able to express himself in his own language."

My life has been spent walking the woods and marshes of South Texas, sketching the forms, making notations, and observing the cycles of our environment. Through this observation and study I feel I am able to go to the heart—the core—the essence withdrawn from nature. Whether it is the life/death cycle of the *Litany Variations,* the elegant color of a purple gallinule, or the cracked, curling form of a dried lake bed, it is still a process of distillation.

I use my studio wall to pin a collage of color references, drawings, ornithologist's observations, and mythology notes before arriving at the final geometric form, the long series of overlapping canvases approximating the shimmering color of an indigenous bird. The slotted half-cruciform shape emphasizes the life/death cycle and the fragility of our environment.

Nancy O'Connor

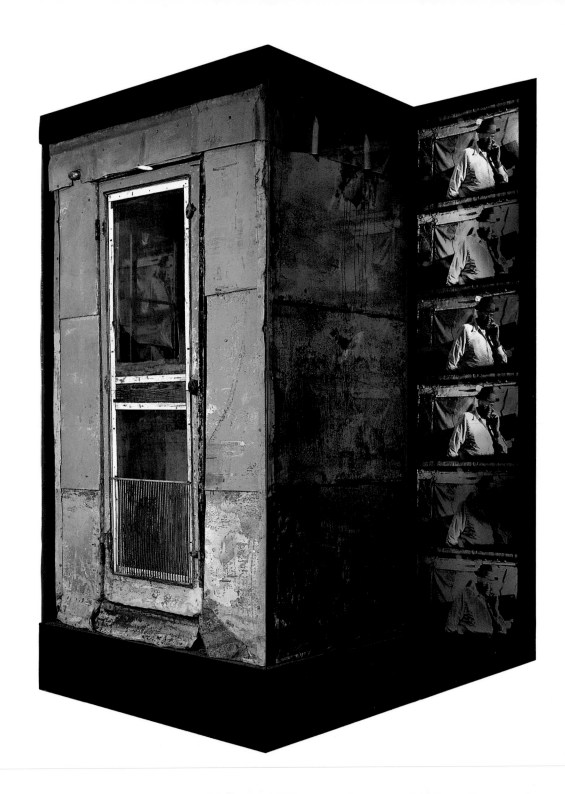

Chicken Ballet (About Milam Thompson)
mixed media, 1985
95″ by 92″ by 37″

Documentation presents the possibility of understanding. Media, the visual tools used for a language of translation. Discovery becomes the reward. Sentimentality, the risk. Presenting a state of mind, the communicative challenge.

I studied photojournalism in college under the direction of J. B. Colson and Garry Winogrand. From the beginning I knew there was something else I wanted to express.

Paradoxically, the camera serves as a protective shield and as a barrier when one enters little-known territories. Vulnerability is not expressed, but perhaps revealed through photographs that carefully conceal the raw exposure of human contact.

The solution may be found in the combination of media. Collected objects represent the culmination of thought. Photographs in multiple altered form present a state of mind in transition— momentary.

The narratives, handwritten by the subjects involved, become the literal translation of that state of mind.

Jorge Pardo

Otiyolqueh
colored pencil, acrylic, enamel on paper, 1981
23″ by 35″

I draw within the context of Latin American art. My works are symbolic tableaus of immediate personal events intertwined with my general experiences in Cuba, Mexico, Peru, and Guatemala, the countries I grew up and matured in. Each nation has triggered emotional and visual responses which have molded my psyche and imbued my ''oeuvre'' with a tragic sense of duality. As a rule my works are small-scaled, highly finished, intimate objects which, while consciously expressing my emotions, are meant to be visually compelling and alluring to the untrained as well as the trained observer.

As a practicing architect and artist, I strive in my works to reflect respectfully the aesthetic and compositional concerns of both professions. Architectural elements from the present as well as the Spanish colonial world are often incorporated, not only for their symbolic value but as a backdrop, or stage within which the main thematic personal content occurs.

For the past nine years Texas and Texans have afforded my family and me the opportunity to expand and contemplate and as such become the perfect interface between my past and future.

Claudia Reese

I work with figures because they immediately communicate. Looking at prehistoric Chinese terra cottas, eighteenth-century and Meissen porcelain figures, shogun warrior armor, contemporary African carved figures, and American folk figures, I can feel a connection between past and present—humanity enduring.

My figures are cultural and temporal crossovers; they are both and neither ancient and contemporary, male and female, human and animal. I see them as a metamorphosis, a frozen moment. They are caught changing from one state to another.

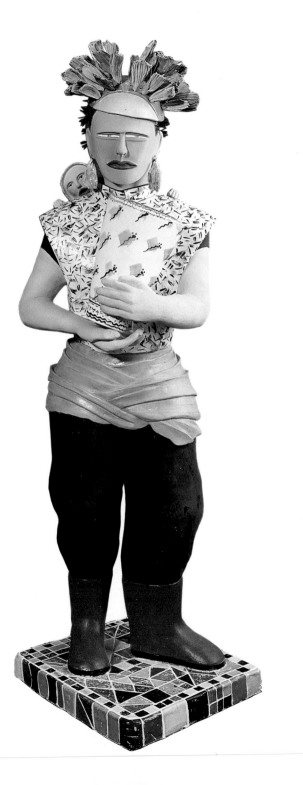

Conflicts
clay, 1984
60″ by 24″ by 27″

Peter Saul

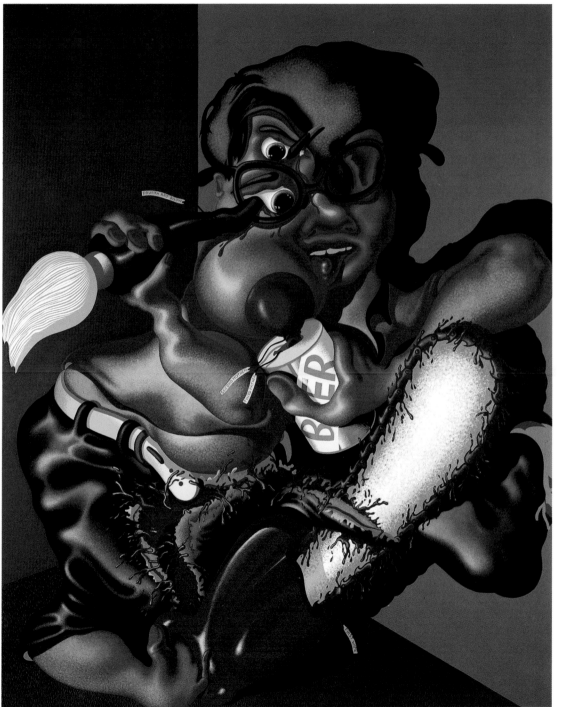

I paint for excitement and my pictures are a mixture of true and false, on various levels of meaning. I hate ''good taste''—it makes me puke. I also hate ''beauty''—even the word makes me feel embarrassed and disgusted. ''Money'' and ''sex'' make me laugh though, so they're O.K.

I lead a very happy, negatively inspired life in Austin, capital of the land of cockroaches, dust storms, and insane summer temperatures. I have a wife and six-year-old daughter, who also like Texas.

Oedipus Junior
acrylic on canvas, 1983
90'' by 72''

Richard Shaffer

One evening, my young son and I were talking about all kinds of things and drawing pictures of faces, dogs, stars, and other stuff.

"Daddy," he asked, "what would happen if there were no circles in the world?"

"Well, Chris," I responded, "I suppose the world would look very different, and I suppose there wouldn't be any more round things like we see every day, you know, like bicycle wheels and revolving planets."

We immediately began to draw these realities on a large sheet of paper in order to see what we were talking about. Our pictures showed us an obvious roundness within many things.

"But, Dad," Chris said, "I know one thing that isn't round."

"What's that?" I inquired.

"A square!" he offered confidently, proud of his discovery.

"Yes, I guess that's so," I replied, sensing that he was waiting for me to jump into this logical trap he had just set out. "Yes, definitely, Chris, you're right. A square is one thing that isn't round. And do you know *why?*"

He looked at me with uncertainty on his face, seeming to wonder if there really was a reason.

"Why?" he challenged, using a stronger tone of voice and suspecting the question more than ever. "Why isn't a square round?"

"Because a square is only an idea in this world," I stated flatly. "It's something you and I just make up."

Chris liked this possibility of invention, and we started to draw again, first making a square and then its variations. Trapezoids, rhomboids, rectangles, and parallelograms filled the surface of our paper. After running through these shapes, Chris questioned me again.

"How do you make an ellipse?" he demanded eagerly, ready to escape the familiarity of straight lines.

"Here's an easy way," I suggested, drawing two identical circles side by side, tangent to each other. "All you need to do is make a third circle outside the edge of these two, holding them both together, and then make two curves from the top and bottom of the big circle."

We carefully drew this picture, swinging the long arcs across the circumferences of the two inner circles. It looked like a pair of eyes, close together, staring back at us.

"Yes, I see it!" Chris exclaimed.

"Yes, that's it!" I exulted, delighted by his early perception of the symmetrical oval, freshly caught between the bending lines. I congratulated him on his quick eyes, and we both fell silent for a moment, looking at our new drawing. It was full of curious marks.

And then, suddenly, I saw something remarkable that excited me. An unexpected surprise, once unseen, now revealed itself clearly through all the lines. On our sheet of paper that night, Chris and I had drawn out the famous theorem in geometry known as *squaring the circle.*

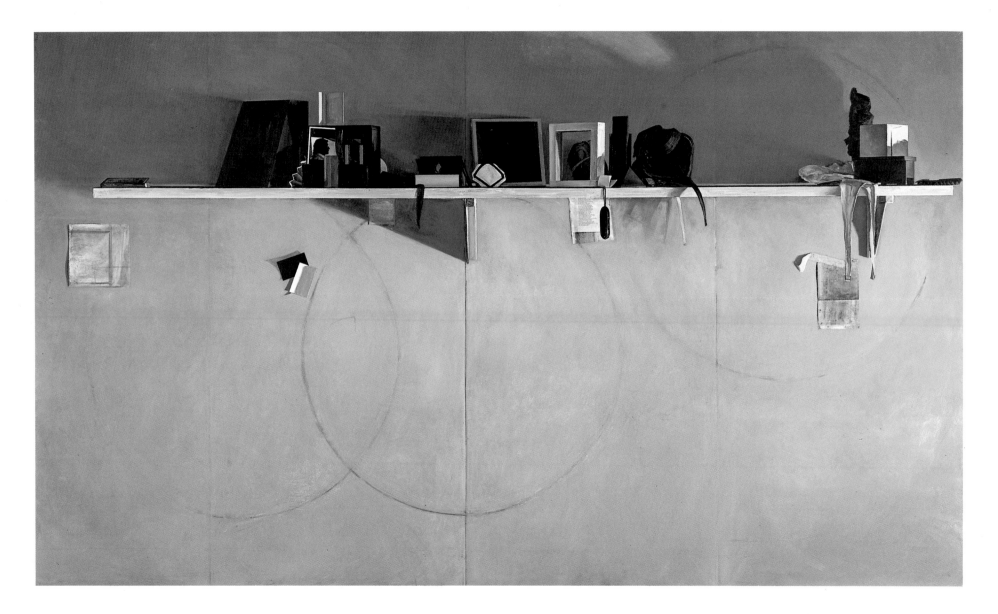

Wall with Shelf
oil on canvas, 1981–83
108″ by 192″

Lee N. Smith III

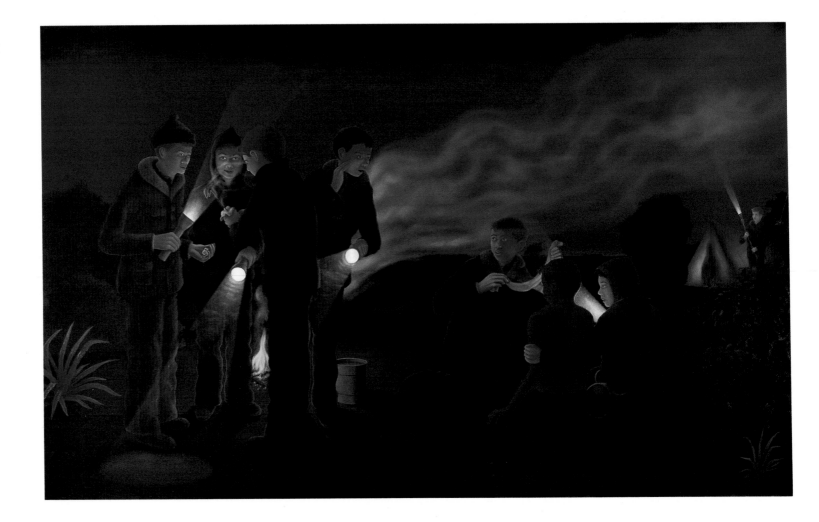

Fire and the Ice
oil on canvas, 1984
78 ½ ″ by 127 ½ ″

My pictures deal with a certain time and place. It was a time when all was ruled by parents, church, and school. The place was the very edge of known suburbia. Through the front door there was row after row of almost identical houses—measured spaces which comprised the world of expected behavior. Through the back gate, escape was easy as we stepped across the Dallas city limits into the unexplored regions of endless hay fields. The simplicity of the landscape allowed us to see with our imaginations. Engulfed in the vastness of the fields, every stone, stick, branch, and piece of cardboard we found was prized. Metal pieces of junk became treasures. To claim the land we dug burrows into the earth and connected them to each other with tunnels. The scraps of wood and branches were used to support the roofs of hay and dirt. Like the prairie dogs we had seen, we were able to vanish through hidden entrances into another world. With found rope, wire, and trees—cut down and hauled back from the creek—we erected towers to rise above the ground. From places like these emerged the rituals by which our adventures were ruled.

Salvage is perhaps the most important link connecting my past to the present. Whether it be the salvage of memory or the salvage of materials, to create something out of nothing is the great imperative.

Gael Stack

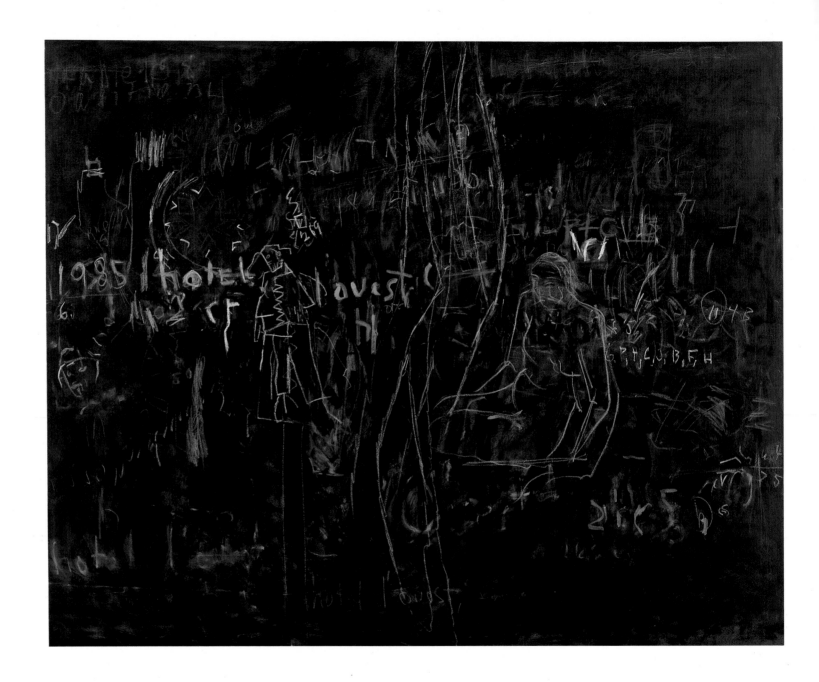

Hotel l'Ouest
oil on canvas, 1985
60″ by 76″

A personal statement I confess to feeling increasingly flummoxed by the idea. What to say? Folly interests me, as do certain regrouping tactics. Sentiment. Comings and goings, large and small. My version of our common stuff. I want the viewer to sense a RECOGNITION in the paintings.

The thing is, while I would prefer to say that which is wise, precise, witty, and true, this is very hard to come by. Perhaps, it is best, instead, to offer a quote that I like very much. "The first pancake is always a lump" (Russian proverb). And I hope that in future readings I do not find myself sorry I have said these things and not others.

Earl V. Staley

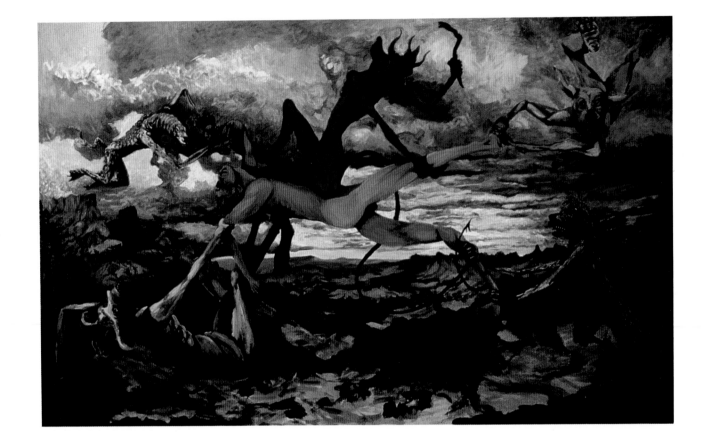

Temptation of St. Anthony
acrylic on canvas, 1977/85
68″ by 109 ½ ″ by 2″

I want my pictures to be visually delight-
ful and intellectually stimulating and to
tell a good story.

Susan Stinsmuehlen

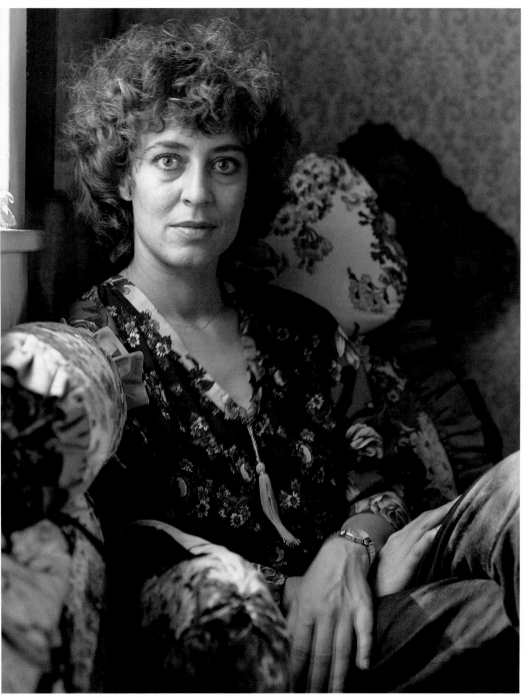

I have avoided adopting a Texas accent, and my python-skin cowboy boots still give me blisters. Fate brought me to Texas sixteen years ago and I have come to know something about myself here. This land is of a spirit (pioneer?) that allows most anything to happen. (Learn to support and promote it yourself, however.)

Fate also introduced me to glass. Though leaded-glass design and production was originally a means of support, I was always searching to make the material mine—to say something from my heart about the world and its infinite mysteries. Though I had previously studied painting and drawing, I found it a more exciting proposition to approach a sheet of glass than one of paper or canvas.

How illusive is the surface of glass. Light is absorbed, refracted, and reflected in ever-changing patterns, creating a state of flux that circumvents specific interpretation. Juxtaposition of various glasses with mixed media—objects and doodads from anywhere—enlarges my vocabulary, allowing the ''precious'' and the mundane to cohabit. I feel my selection of materials to be a very democratic process. Though our society (and the art world) stratifies according to traditions, historical precedents, and relative values, I want my work to incorporate disparate elements in a nonpejorative fashion.

My influences can be anything. Contradicting and distorting the history and traditions of my medium, stained glass, has been fun. Integrating the concerns of twentieth-century painting with historical decorative motifs and with the Mexican attitude toward materials dramatizes the common ground that diverse ideas and imagery share. Relating direct personal experience through metaphor, creating a narrative for my time that incorporates any time, and using ideas from anywhere, all help me to understand (?). I hope to create clarity, touched by humor, out of chaos.

My early years with my family were spent moving from one midwestern town to another. I have achieved my own independence and sense of stability here in Texas. I have watched my son and my city (Austin) grow formidably. The sense of home and place has made Austin a good town in which to work—to sort and assimilate ideas uninterrupted. But regular travel has also been integral to my life and creativity. The larger "family" I maintain is the glass-art scene— an active national community of artists working in glass with whom I share ideas through conferences, workshops, lectures, personal visits, and enduring friendships.

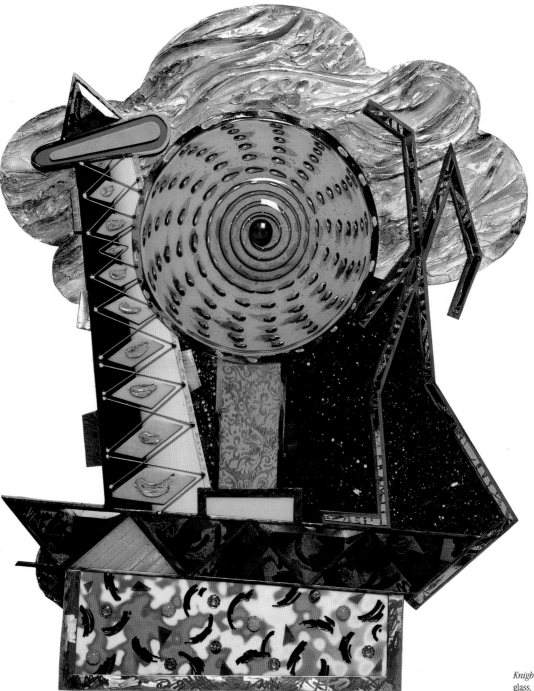

Knight Giant, Oil and Wind
glass, metals, paint, wood, 1985
32″ by 27″

James Surls

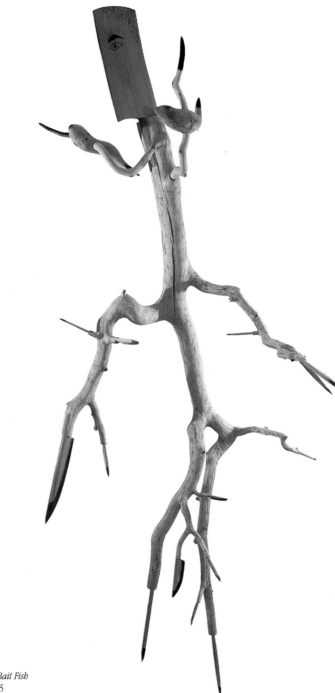

Meat Man and the Bait Fish
oak and hickory, 1985
124" by 50" by 42"

It's the puff I'm after. The hocus-pocus the Merlin types used to produce. I love it that they could wave a wand and from a flash of light and a puff of smoke would appear an object. I make objects. It takes so long. It would take me a lifetime to build just what I can dream in one day. I want a hundred lifetimes and one day. I do my best.

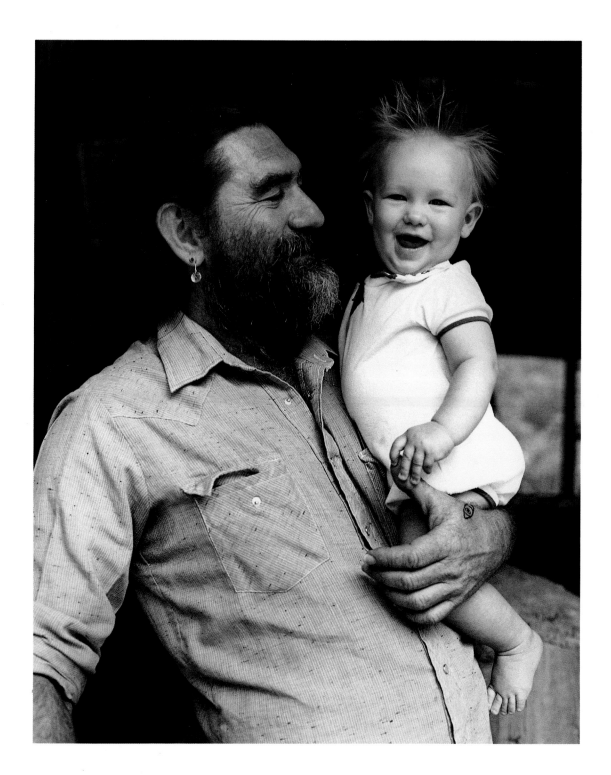

Richard Thompson

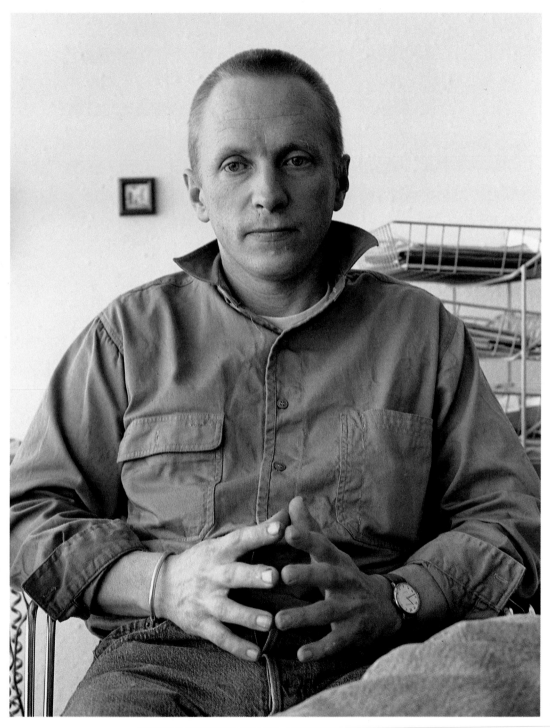

Fairytale
oil on canvas, 1985
66″ by 104″

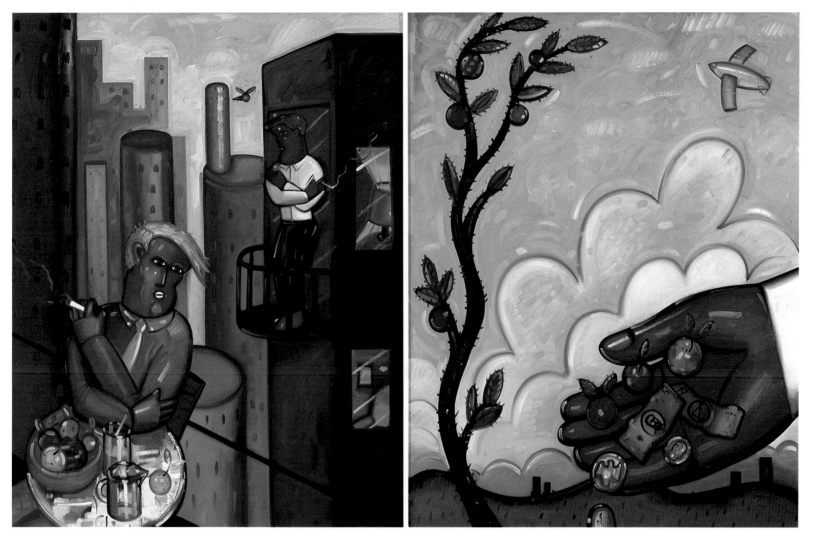

I have a great studio, an old storefront on a busy street with big windows, high ceilings, and a red concrete floor. It has a back door that opens onto a yard—the neighbors', but at least I have a bit of landscape. This is the best studio I've had in a few years.

Down the street five blocks is my house. I have a good teaching job right now, so I have been able to buy my first house, the first house I've really lived in since I left home for college. Now I have a place for some family life. All this is in a great neighborhood with some good restaurants and near my friends.

I enjoy painting my paintings now more than ever. I make a lot of pictures, from little, tiny pictures up to big, hard-to-store pictures, but they are all a part of my process. A few years ago I became more interested in Nothing, the everyday, the commonplace as subject matter. At first I didn't realize that this was a new direction for me; now it is most exciting. I am painting the Nothing of the space between two objects; the poise of a little helicopter over a smooth hill; the complexity of simple still-life setups; abstractions using pseudoscientific gadgets; the richness of depicting even the most simple human moments. I am finding great reward in framing little alignments like the way a tree limb bending with fruit almost touches a painted human face; or the way I can picture distant buildings in almost the same space as a pile of fruit on a wooden table.

What is missing from this experience is easy access to great mountains with continuous fly fishing for trout. Every now and then I slip some little, distant mountains into my pictures to keep touch with that part of my life.

Patricia Tillman

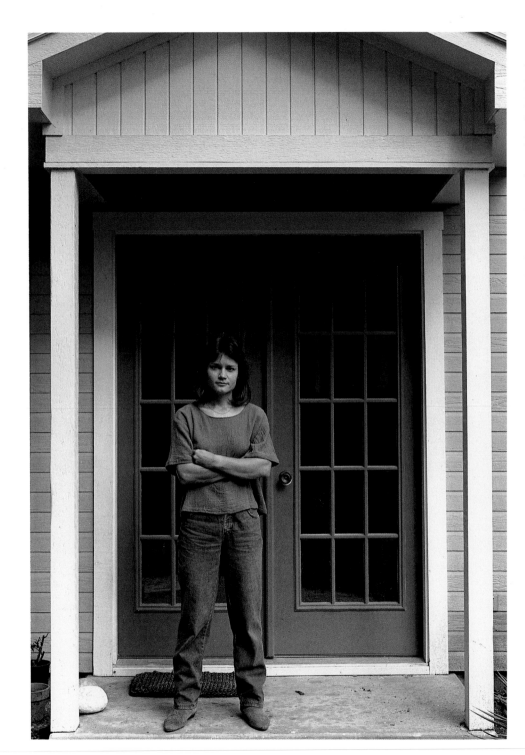

Central Texas is where I developed an interest in art. I remember looking at books and magazines at a neighbor's house as a child and being very impressed with Picasso's drawings. I could draw well and my family and friends encouraged me to study art. When I started college, I began visiting art museums regularly in Dallas, Fort Worth, and Houston.

I studied painting at the University of Texas at Austin and went to graduate school at the University of Oklahoma. In those years my paintings were concerned with geometric form and shallow space. I was particularly interested in the work of Matisse and Diebenkorn. When I was a graduate student the source for the geometry in my work came from things around me, the walls, windows, and doors of my studio. Seeing some examples of structuralist film making by Michael Snow and others affected the way I thought about painting. Eventually, I became more involved with the idea of object making and shifted to wood as a primary material rather than paint. Instead of making references to or illusions of something, I began replicating windows or architectonic forms which were produced in response to what was around me. I began to focus on my environment as a source for my work.

My interest in geometry and environment and eventually my marriage also contributed to a fascination with architectural forms. I am frequently struck by images I have probably seen many times,

but suddenly they take on new meaning and become part of my work. The meaning may not be profound or have any personal relevance to anyone but myself, but it becomes a part of my art and motivation. The formal symmetry is often a reference to married life.

I'm not interested in being explicitly narrative, but some of the forms I use relate to specific places or events in my life. Some of the constructions are in response to my relationship to family and society as well as to the environment. I think of the objects as "landmarks" in my life that commemorate experiences. I want them to relate in some way to common experience, but I am also interested in unexpected juxtapositions and relationships. No "proper response" is expected of the viewer other than one that is individual to him or her.

My family has lived in Texas for several generations. My father was in the service when I was born, so my life here actually began in the early sixties. I grew up in a large Catholic family in a predominantly Protestant community. Perhaps this had some effect on my art, although, if so, indirectly. The reference to religious forms is intentional, but not of primary importance to me. I seek a formal intensity, but I never want my work to become unapproachable or aloof. I am more interested in the quality of day-to-day living, and this attitude is emphasized in the secular form and intent of my work.

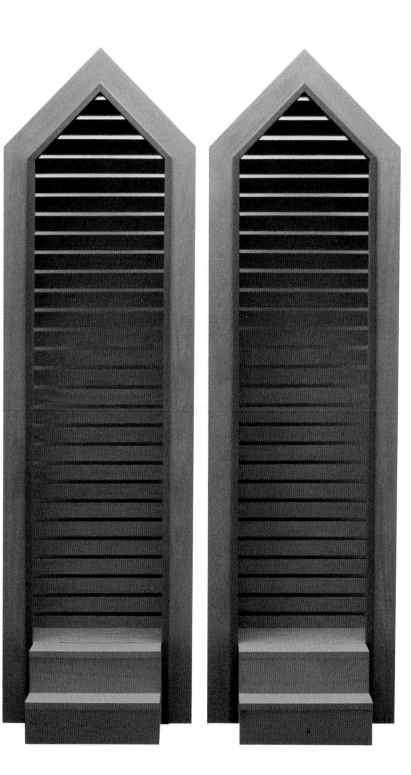

Two Niches
wood, latex paint, 1983–84
72″ by 44″ by 19 ⅝ ″

99

Francis Xavier Tolbert[2]

My parents said to me when I was a very young boy that they thought I was retarded I guess I misunderstood I thought they said I should become an artist. . . .

A B C D E F G H I J K L M N O P Q R S T U V W X Y Z in various arrangements form the names of most of the people, places, and things I would like to thank so very much for stimulating all my motions in life! (Especially I would like to thank A. = Hazie Short, Anna May Fishsticks, Miss Annie, and an extra standing ovation to Thelma and A. T. Stautberg for keeping me from drawing people's necks too long.)

My main highly personal secret to my success as an artist is, ''I've got think'n' on my mind.'' Remember . . . ''Your life is what you make it.''

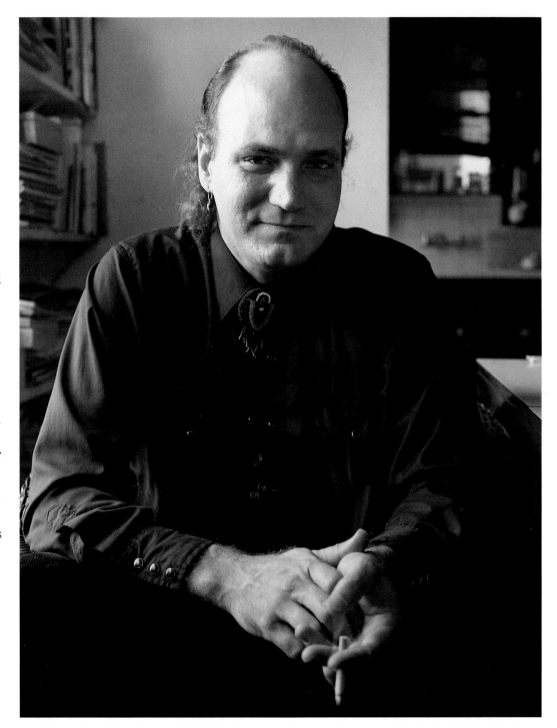

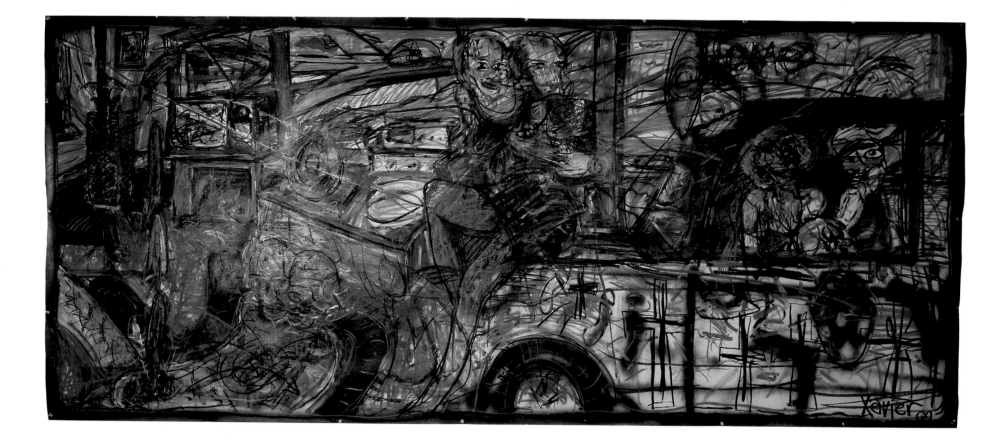

X. + A. 'Home' Good Luck
oil, mixed media on paper, 1984
60″ by 144″

John Tweddle

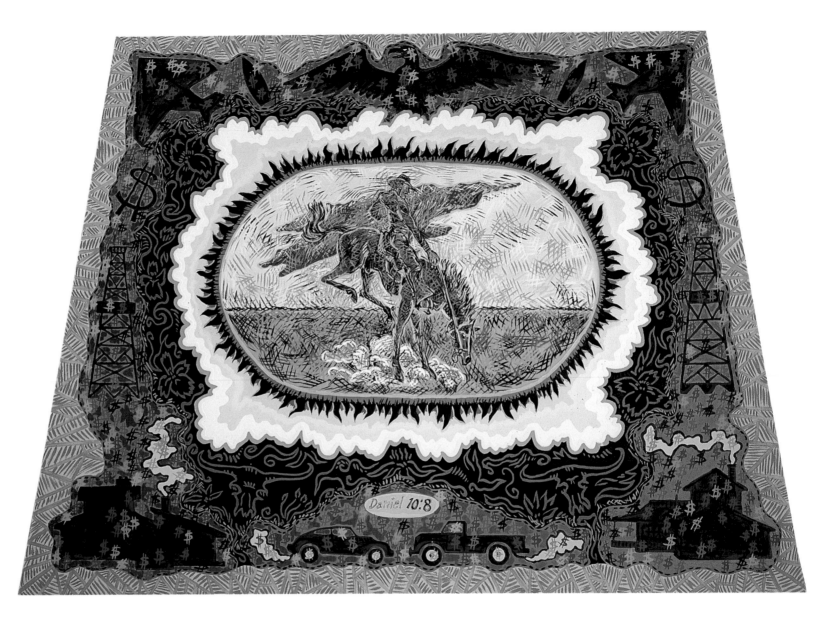

Vision of Oklahoma
oil on canvas, 1983
66 ¼ ″ by 96 ¾ ″

When I was four years old, I liked to stare at wallpaper and see pictures, so I wanted to make pictures about my feelings and I got hooked.

I love people and everything in life and I like to fantasize about common events on a cosmic scale.

What I like best is research, experiments and explorations in seeking new ways to express our human condition.

I moved to Texas because my parents live here and they are getting older and I wanted to be around.

I still show my work in New York and I love to travel there. I'm crazy about driving cars or trucks anywhere, anytime.

I have six children and four grandchildren and two ex-wives. I'm now in love with a marvelous Chinese lady who is a therapist.

I don't read anything much, since I prefer to think my own thoughts.

Bob Wade

As a young buckaroo, I used to sit on the lap of my second cousin Roy Rogers.

He was making rodeo appearances in Texas towns where I grew up the son of a hotel manager.

It was in the Texas towns Beaumont, Galveston, San Antonio, El Paso, and Marfa (where the movie *Giant* was being filmed) that I learned the ways of the "Texas Myth." Gigantism, bigger than life scale, outrageous humor and exaggerations still play a big part in my life and work. I love to make "visual remarks" about sacrosanct stuff like armadillos and boots, coyotes and cowgirls, plus machine guns and Indians.

How can you not love the Southwest, with its roadside snake farms, chickenfried-steak truck stops, and good ole boys "ridin' the range" in pickups with gun racks!

Who wouldn't want his picture taken with those giant mariachi-band frogs on a flatbed, or with the forty-foot-high boots in San Antone?

While many folks are determined to transform Dallas into Europe, I had great pleasure "exporting" my twenty-five-foot travel trailer to Paris so that Biennale visitors could experience an upside-down bucking bronco and a two-headed calf.

The Museum of National History in New York houses a six-foot crocodile skull that was part of a fifty-foot-long critter from Big Bend, Texas, and the

Lone Star Cafe on Fifth Avenue acts as a giant sculpture stand for my forty-foot *Giant Iguana*.

Maybe all this is "Neo-Western" art. I hand color ten-foot-wide photos of cowgirls and cactus-filled sunsets, I make twelve-foot-long bronze bucking 'dillos, and I construct "noble savage" profiles in high relief out of fence posts.

Much of this work is representative of Texas humor. It is garish, resilient, disorderly, perverse, and helps perpetuate the idea of the "Professional Texan" with all its "tall tales."

Texans as presidents, presidents as cowboys along with countless Western movies, TV shows, boots, jeans, and Country and Western music all combine to make places like Texas "mythical" and cultural curiosities.

Perhaps the universal interest in being a real "cowboy" with all its anthropological offshoots will provide me with material for my work for a while.

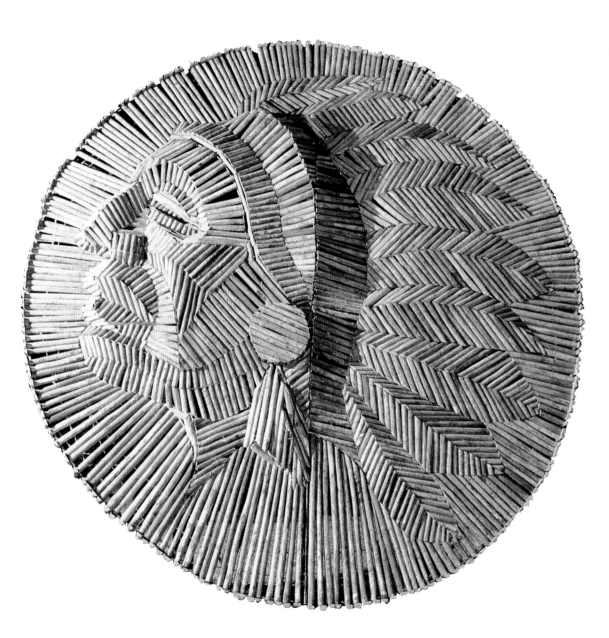

Big Indian Head
treated wood on steel structure, 1985
240″ by 240″ by 18″

Susan Whyne

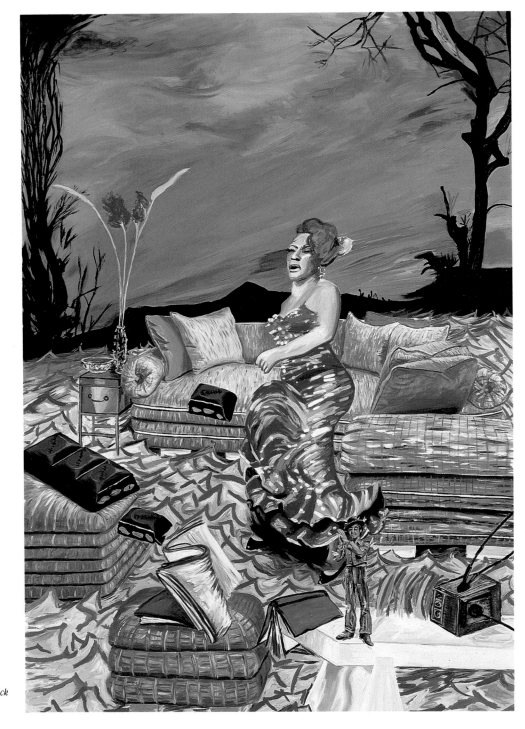

Flamenco and the Knick-Knack
oil on canvas, 1983
90″ by 65″

I think I took to art as a kid to escape from group competition and public activity. It was a private activity. I got encouragement to do it, since I was a klutz at everything else, so it stuck. Now it's a terribly public and competitive thing to do! I went to kids' classes at the Art Students League in New York City on Saturday mornings. In Mrs. Katz's class, I made pastel drawings for years of the most unusual still lifes of strange and elegant fruits, vegetables, and museum antique bowls and vases arranged by the teacher. They were like landscapes of fantasy, and I believe they are responsible for making me enjoy shapes, color, and mysterious sensuality. I also got to escape the all-American high-school scene by going to an art high school in New York—no football and cheerleader stuff and I'm so grateful for that. Escape again. When at eighteen I traveled cross-country to San Francisco, I started to get my own ideas for imagery for the first time. I still use the sensation of moving through movie space, going from scene to scene like a car pushing through time and space. I also saw the U.S.A. outside of New York for the first time and from then on never wanted to go back. I lived in the San Francisco area for ten years after that, where I was continually overwhelmed by architecture, gardens, personal invention of homeowners' yards, and landscaping. So I painted these houses, stairs, entrances, gardens. I still paint domestic landscape. We mold nature and make it comfortable for ourselves. After growing up in dirty, overcrowded New York, I am still amazed at privacy and personal landscaping. I love comfort and my greatest fear is the loss of it, in a personal sense and in the greater sense of what is happening to this planet. The difference between safety and fear, comfort and

want is a real preoccupation for me.

I've been in Texas for eight years. I came for what I thought would be a one-year job. I still feel like a tourist and that's fine. It's fascinating to me in a very different way than California—manners, history, landscape. Austin is very lush, green, lots of water. Not what one usually thinks of as Texas. Swimming and hot, hot weather—good fuel for my images.

Danny Williams

An artist friend I admire speaks of his desire to create works which convey a sense of hope. I support his goal, and for my own part, emphasize a related intent: while search remains a most vital process, to discover, to arrive, to know is the real salvation.

> Now you shall see the Temple
> completed:
> After much striving, after many
> obstacles;
> For the work of creation is never with-
> out travail;
> The formed stone, the visible crucifix,
> The dressed altar, the lifting light,
> Light
> Light
> The visible reminder of Invisible Light.
> —T. S. Eliot

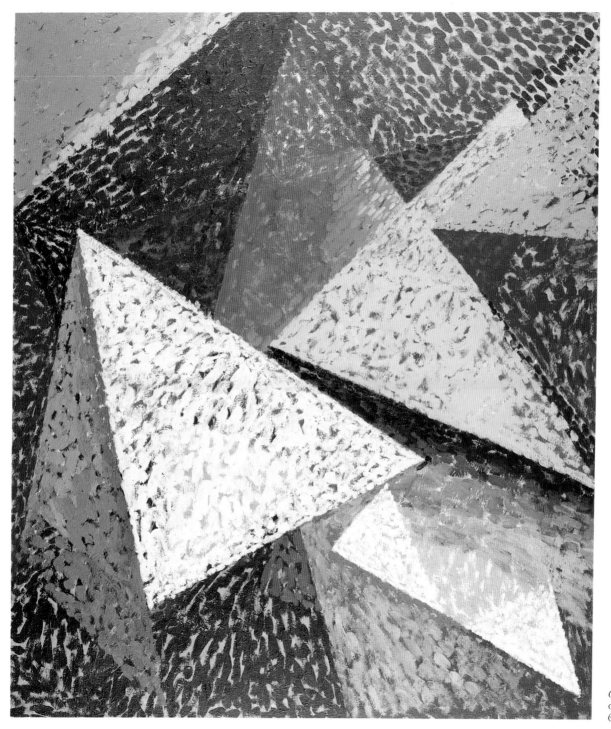

Cubic Light
oil and magna on canvas, 1983–84
60″ by 51″ by 2″

Bill Wiman

The elongated figure in the paintings is that tenuous claim by the individual to existence in a mysterious and turbulent space. A slight turn this way or that might cause the image to decrease or disappear altogether. The figure constantly struggles for its place against an ever-encroaching paint surface. The environment around the figure pushes against the figure, sometimes overlapping or dissolving the boundaries contouring the figure. The paint marks describing the figure are always dwarfed by the gigantic and swirling marks of the space around the figure, just as the efforts to establish individuality always seem so small in comparison to the forces of nature and society at large. Within the confines of the elongation, to make a mark that will compete with the space around the figure is next to impossible. Within the elongation, every slight distortion has immense implications. Just a small difference in the size of one eye compared to the other may cause one side of a face to drop back in space; thus the constant struggle to maintain equilibrium.

Yet, the individual survives. Individual traits can be found. The figure does exist in three dimensions. There is always a light side and a dark side of the form declaring the actual physical existence of the individual. Indeed, the body itself is the starting place of existence. So long as there is a breathing body, we must compensate for its existence. Hope is not lost for a feeling of existence. Indeed, the feeling of existence has its beginning in the struggle of the individual against infinite possibility and coincidence.

Focus is on the eyes and the mouth, both of which are an integrated vehicle of expression, one incomplete without the other. Perhaps other people search the eyes for expression while listening to the voice. But possibly because I am just slightly hard of hearing, I concentrate on the mouth as well as the eyes, searching the mouth's shapes for added expression while listening to the words spoken.

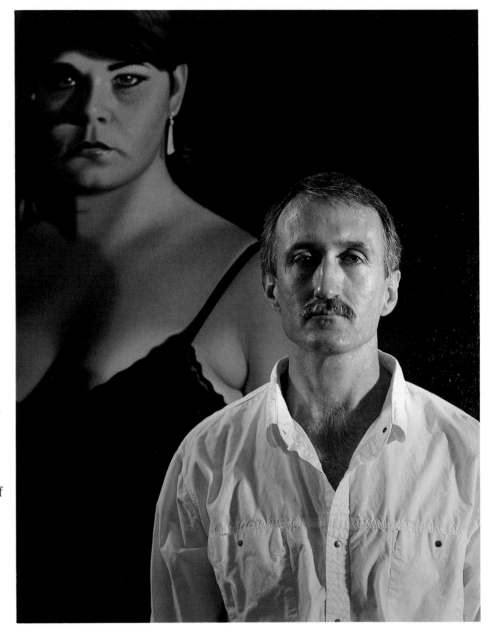

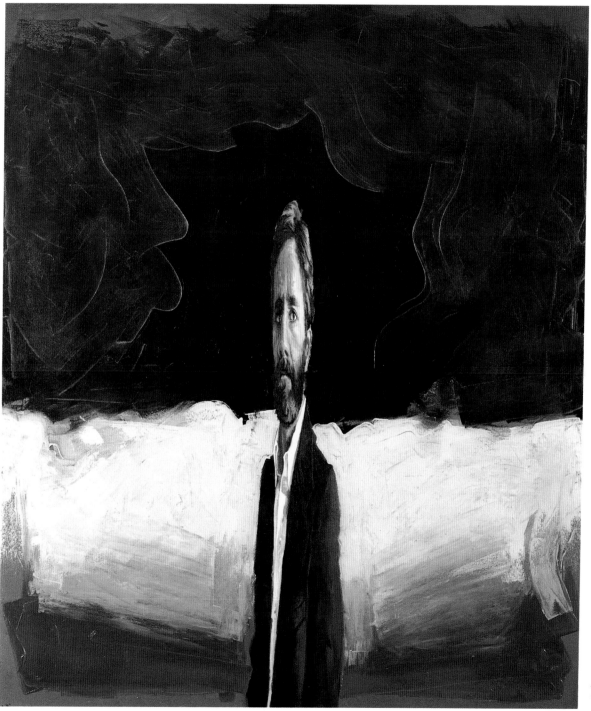

Heat from a Black Sun
oil on canvas, 1984
78″ by 66″

Dee Wolff

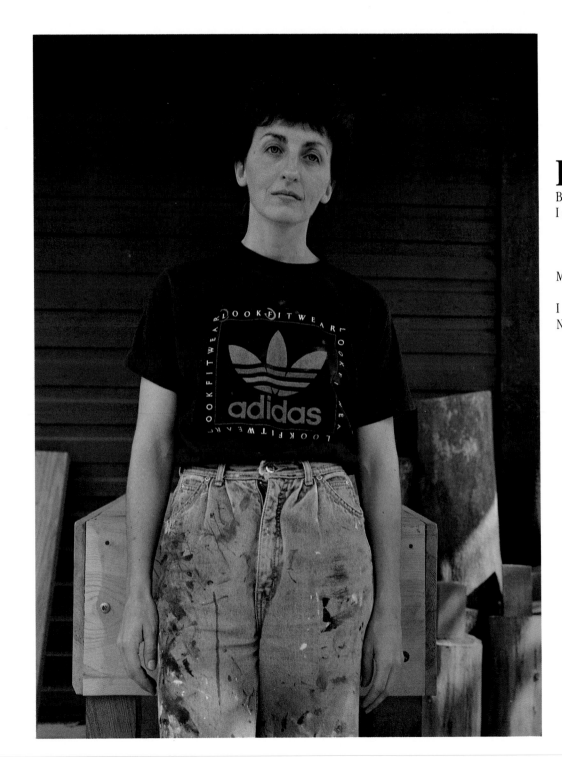

I love to paint.
I love my pictures.
Both are my teachers.
I sit and look at the canvas. An image
 appears. I paint it. Sometimes there are
 many images and sometimes there is
 one.
My life and my paintings happen in the
 same way.
I once thought that I knew some things.
Now, I only know that I don't know.

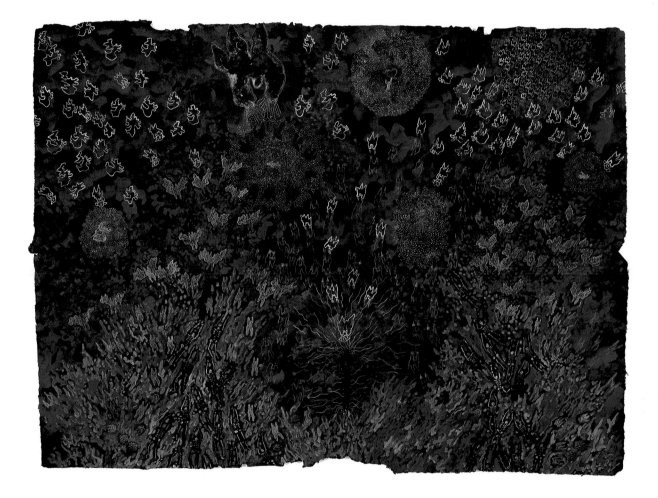

A Dream
gouache, 1985
20″ by 26″

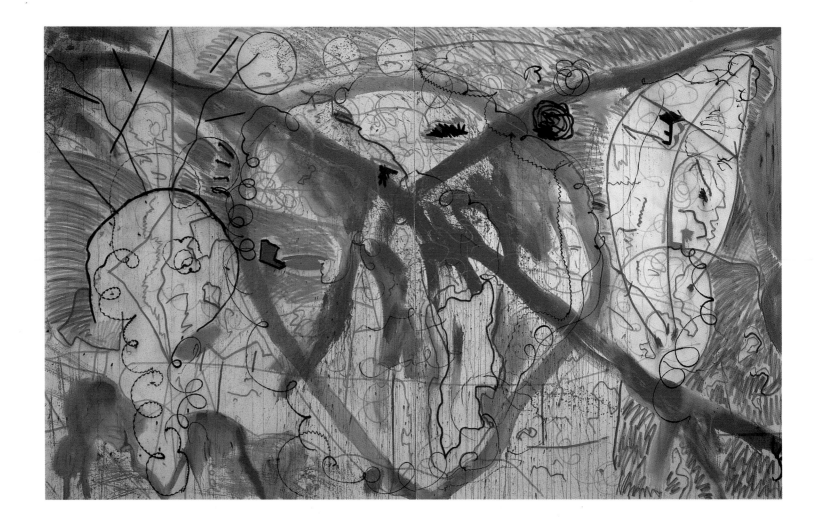

Untitled
mixed media, 1983
96″ by 156″

If it's worth doing, it's worth overdoing.

Robert Yarber

The people in my paintings are robotic, they are unconscious, participating in some primordial drama in which they play passive agents. They are schemata describing hypothetical behavior patterns. To the degree that they are aware, it is of their own internal discomfort, and yes, perhaps their ecstasy.

The need is to evade or escape the machination of the environment they inhabit. Yet they are seduced, unconscious as they are, by the luminosities of their postmodern world, bewitched by the melodrama of a confected reality, as if to say, "Life is television." Though their lust is real, their kisses are Novocain kisses, rubbery and desperate. Their pleasures are furtive. The sky above them is their ideal, and the emptiness beneath them is their refuge.

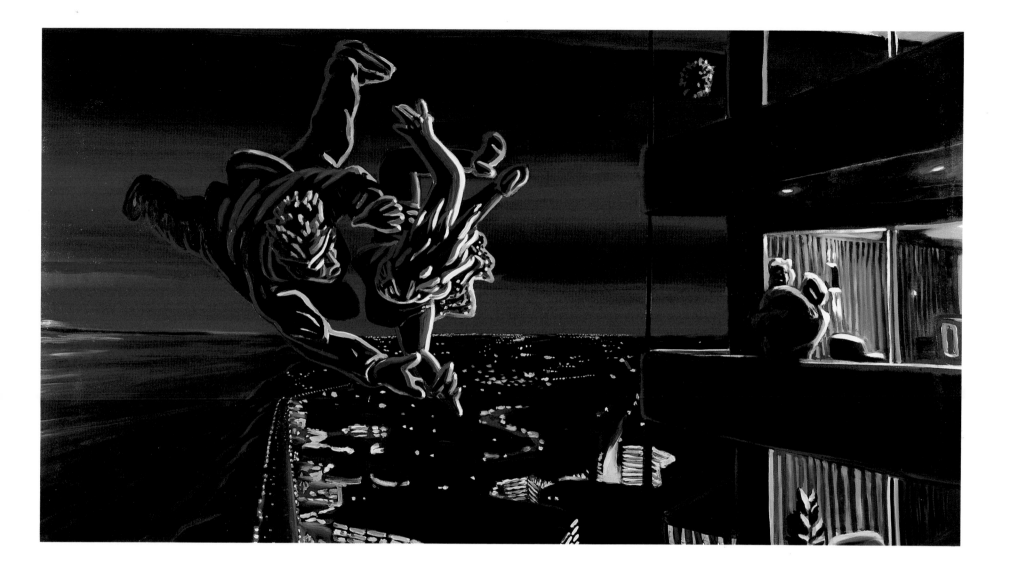

Bill Fall
oil and acrylic on canvas, 1984
72″ by 132″

Artists' Representatives

Santa C. Barraza
Intar Latin-American Gallery
420 West Forty-Second Street
Second Floor
New York, NY 10036

David Bates
John Berggruen Gallery
228 Grant Avenue
San Francisco, CA 94108
Charles Cowles Gallery
420 West Broadway
New York, NY 10012
Betsy Rosenfield Gallery
212 West Superior
Chicago, IL 60610
Texas Gallery
2012 Peden
Houston, TX 77019

Ed Blackburn
Moody Gallery
2815 Colquitt
Houston, TX 77098
Peregrine Press & Gallery
2604 Main Street
Dallas, TX 75226
Barry Whistler Gallery
2708 Commerce
Dallas, TX 75226

Derek Boshier
Texas Gallery
2012 Peden
Houston, TX 77019
Totah-Stelling Art
152 Wooster
New York, NY 10012

Martin Delabano
DW Gallery
3200 Main Street
Dallas, TX 75226
Tilden-Foley Gallery
4119 Magazine Street
New Orleans, LA 70115

James Drake
Texas Gallery
2012 Peden
Houston, TX 77019

Vernon Fisher
Butler Gallery
2318 Portsmouth
Houston, TX 77098
Barbara Gladstone Gallery
152 Wooster
New York, NY 10012

Roy Fridge
Moody Gallery
2815 Colquitt
Houston, TX 77098

Harry Geffert
Fort Worth Gallery
901 Boland
Fort Worth, TX 76107

Joseph Glasco
Gimpel & Weitzenhoffer Gallery
1040 Madison Avenue
New York, NY 10021
Meredith Long & Co.
2323 San Felipe
Houston, TX 77019

Joe Guy
Adams-Middleton Gallery
3000 Maple Avenue
Dallas, TX 75201

John A. Hernandez
DW Gallery
3200 Main Street
Dallas, TX 75226
Moody Gallery
2815 Colquitt
Houston, TX 77098

Dorothy Hood
Meredith Long & Co.
2323 San Felipe
Houston, TX 77019

Luis Jiménez
Phyllis Kind Gallery
136 Greene Street
New York, NY 10012

Thana Lauhakaikul
Architectural Arts
9400 North Central Expressway
Dallas, TX 75231
Art South, Inc.
4862 MacArthur Boulevard NW
Apt. 102
Washington, D.C. 20007
Galerie Ravel
1210 West Fifth
Austin, TX 78703

Robert Levers
Patrick Gallery
721 East Sixth Street
Austin, TX 78701
Watson Gallery
3510 Lake
Houston, TX 77098

Bert Long
Butler Gallery
2318 Portsmouth
Houston, TX 77098

Jim Love
Janie C. Lee Gallery
1209 Berthea
Houston, TX 77006

William Jackson Maxwell
Davis/McClain Galleries
2637 Colquitt
Houston, TX 77098
Caroline Lee Gallery
4010 Broadway
San Antonio, TX 78209

David McManaway
Eugene Binder Gallery
2701 Canton Street
Dallas, TX 75226

Melissa Miller
Holly Solomon Gallery
724 Fifth Avenue
New York, NY 10019
Texas Gallery
2012 Peden
Houston, TX 77019

Jack Mims
Moody Gallery
2815 Colquitt
Houston, TX 77098

Nic Nicosia
Dart Gallery
212 West Superior #203
Chicago, IL 60610
Texas Gallery
2012 Peden
Houston, TX 77019
Totah-Stelling Gallery
152 Wooster
New York, NY 10012

Madeline O'Connor
Moody Gallery
2815 Colquitt
Houston, TX 77098

Nancy O'Connor
Moody Gallery
2815 Colquitt
Houston, TX 77098

Claudia Reese
Willingheart Gallery
615-A East Sixth Street
Austin, TX 78701

Peter Saul

Rena Bransten Gallery
254 Sutter Street
San Francisco, CA 94108

Allan Frumkin Gallery
50 West Fifty-Seventh Street
New York, NY 10019

Texas Gallery
2012 Peden
Houston, TX 77019

Richard Shaffer

L. A. Louver Gallery
55 North Venice Boulevard
Venice, CA 90291

Lee N. Smith III

DW Gallery
3200 Main Street
Dallas, TX 75226

Patrick Gallery
721 East Sixth Street
Austin, TX 78701

Texas Gallery
2012 Peden
Houston, TX 77019

Gael Stack

Janie C. Lee Gallery
1209 Berthea
Houston, TX 77006

Earl V. Staley

Phyllis Kind Gallery
136 Greene Street
New York, NY 11012

Texas Gallery
2012 Peden
Houston, TX 77019

Susan Stinsmuehlen

Matrix Gallery
912 West Twelfth Street
Austin, TX 78703

Kurland/Summers
8742-A Melrose
Los Angeles, CA 90069

James Surls

Butler Gallery
2318 Portsmouth
Houston, TX 77098

Richard Thompson

William Campbell Contemporary Art
4935 Byers
Ft. Worth, TX 76107

Harris Gallery
1100 Bissonnet
Houston, TX 77005

Space Gallery
6015 Santa Monica Boulevard
Los Angeles, CA 90038

Patricia Tillman

Fort Worth Gallery
901 Boland
Fort Worth, TX 76107

John Tweddle

Oil and Steel Gallery
30 - 30 Vernon Boulevard
Long Island City, NY 11002

Texas Gallery
2012 Peden
Houston, TX 77019

Bob Wade

Janie Beggs Fine Arts, Ltd.
213 South Mill Street
Aspen, CO 81611

Marianne Deson Gallery
340 West Huron
Chicago, IL 60610

Hadler/Rodriguez
2320 Portsmouth
Houston, TX 77098

Elaine Horwitch Galleries
4211 North Marshall Way
Scottsdale, AZ 85251

Morgan Gallery
1616 Westport Road
Kansas City, MO 64111

Segal Gallery
568 Broadway #502
New York, NY 10012

Susan Whyne

Air Gallery
918 West Twelfth Street
Austin, TX 78703

Texas Gallery
2012 Peden
Houston, TX 77019

Danny Williams

Butler Gallery
2318 Portsmouth
Houston, TX 77098

Barry Whistler Gallery
2708 Commerce
Dallas, TX 75226

Bill Wiman

Adams-Middleton Gallery
3000 Maple Avenue
Dallas, TX 75201

Patrick Gallery
721 East Sixth Street
Austin, TX 78767

Dee Wolff

Watson Gallery
3510 Lake Street
Houston, TX 77098

Dick Wray

Moody Gallery
2815 Colquitt
Houston, TX 77098

Robert Yarber

Asher/Faure
612 North Almont Drive
Los Angeles, CA 90069

Sonnabend Gallery
420 West Broadway
New York, NY 10012

Designed and produced by Ed Marquand Book Design
Printed by Dai Nippon Printing Co., Ltd., Tokyo